THE DIGITAL DARKROOM

BLACK-AND-WHITE TECHNIQUES USING PHOTOSHOP

By George Schaub

SILVER
PIXEL
PRESS®

Rochester, NY

The Digital Darkroom

BLACK-AND-WHITE TECHNIQUES USING PHOTOSHOP

Written by George Schaub

Published in the United States of America by
Silver Pixel Press®
A Tiffen® Company
21 Jet View Drive
Rochester, NY 14624
Fax: (716) 328-5078

Second Printing, 2000

Design by Mary McConnell

Printed in Belgium by Die Keure n.v.

ISBN 1-883403-51-0

Library of Congress Cataloging-in-Publication Data

Schaub, George.
 The digital darkroom : black-and-white techniques using Photoshop
/ written by George Schaub.
 p. cm.
 ISBN 1-883403-51-0
 1. Photography--Digital techniques. 2. Image processing--Digital
techniques. 3. Adobe Photoshop. I. Title.
TR267.S33 1999
771'.46'028566--dc21 98-44303
 CIP

Dedication

To my father, who showed me that first print coming up in the developer.

To Dennis Simonetti, whose later guidance proved pivotal in my dedication to black and white.

To Grace, whose understanding and patience allowed our living room to become
our first digital darkroom.

To Lucy, whom we all miss very much.

I would also like to thank Eastman Kodak Company for their support in supplying me
with equipment and materials, and Marti and Mimi, who work too hard.

Contents

■ Introduction

A misconception about digital imaging is that it is foreign territory, alien to the very concept of photography. Clearing up that misconception and making a transition between the two types of imaging is what much of this book is about. In truth, many of the fundamentals of digital imaging are intimately related to conventional (silver-halide) photography. Specific techniques may differ, but the issues that are addressed in both forms of image enhancement are very much the same. The photographic industry's focus on digital techniques is an affirmation that this new mode of imaging offers expanded creative opportunities and new forms of expression to every photographer.

It is in the translation of conventional photography to digital technology and practice that the greatest confusion may reign. But once parallels are drawn, those with even a rudimentary grasp of black-and-white photography will begin to understand how the two media are similar. For those who already have darkroom experience, the digital realm will be intuitive and will open new doors and offer potential for every image. Digital techniques offer alternate methods for controlling tonality, contrast, and other creative aspects of the craft, which were once available only to those with extensive darkroom experience.

Digital imaging does not replace silver-halide photography. While digital cameras do allow us to work entirely in the digital realm, most photographers will still use images they have made on film as their starting point. For this photographer, digital imaging has had its greatest impact on what happens after the image has been captured on film—the transformation of the photographic image to the digital form and all that follows.

Before we begin our explorations, I'd like to briefly discuss why I've undertaken this book. I have been a black-and-white printer for almost 30 years, have written numerous articles and books on the subject, and have taught at the college and workshop levels. I earned my living for 12 years as a custom printer. I consider black-and-white to be the most expressive form of photography, and frankly, it's what I know best.

My emphasis in my photography, writing, and teaching has always been on exploring ways to interpret and enhance the image. I consider the digital darkroom to be another tool for the black-and-white photographer and printer. I also feel that black-and-white photographers have been somewhat ignored in the digital realm and that there has been a lot of confusion about just how they fit into this brave new world. I hope that my knowledge and experience as a photographer and printmaker will help other photographers make the transition from one form of imaging to another, because I know full well the benefits that the digital world can bring.

With that in mind, I begin this book with a description of the digital imaging "chain" and compare its correlations to conventional photography. I then discuss equipment and setup specifications, image resolution, and how the image's intended use controls many of the initial tasks you do. These all lead to the main body of the book, which takes a workshop approach. Conventional photographic techniques, such as contrast control and selective exposure, are translated into digital techniques, which are demonstrated to illustrate how to create effective black-and-white images. A wide variety of images are used to show how both "problem-solving" and creative interpretation might be applied in the digital darkroom. Creative options and special effects are explored to offer further insight into how digital imaging can yield effective and exciting results.

My goal, then, is to clarify how black-and-white photography can be enhanced through computer imaging techniques and to articulate it in such a way as to ease the transition between the two for you. Those who have worked in the darkroom know that taking the picture is only the first step; it is in the processing and printing that the full potential of the image is realized. That has always been the reason for getting involved in the darkroom. That reason still holds true for those who now aspire to realize their visions in the digital realm.

What are the factors that may induce you to pursue the digital route? Let's briefly explore some of them and consider what digital photography has to offer.

The end use of the image should be the primary consideration in your work. For editorial and commercial photographers, images created for the magazine, book, and advertising markets are being requested (and delivered) increasingly as digital files. If prints are required for reproduction, going digital will often offer greater speed and convenience than the conventional darkroom route. You can even convert your images to halftones and can get as deep into the reproduction process as you desire. This opens new avenues for photographers considering self-publishing ventures or those who want to work closely with a printer or publisher.

Digital images can be easily manipulated to deliver optimum quality for virtually every reproduction venue, be it a book, magazine, poster, or brochure. While image preparation for each of these venues requires some variation, working with a digital file allows for increased efficiency throughout the entire process.

If you have developed a market for your fine-art silver prints, you may be tempted by the siren call of digital imaging but hesitant to make the shift. Be aware that the market for fine-art digital images is beginning to emerge and that there are a growing number of print size and paper options. New printers and paper surfaces have made photo-quality imaging from digital sources a reality; competition among manufacturers has made these printers affordable for the home or studio user.

If you print for pleasure or for exhibition, you'll soon find that the digital darkroom offers an ease of use unmatched by conventional modes. Simply stated: Black-and-white images are more easily created with more interpretive options by going the digital route. This does not imply that silver prints no longer have their own niche; indeed, for some images and purposes, conventional silver prints are still the way to go.

A major factor in digital imaging's favor is the time it takes to get a print out the door. If you are constantly on a deadline and must deliver images quickly, your best bet can often be to go the digital route. With the digital package you can download the image (bring it from archive to computer), manipulate the image (for example, adjust the contrast to optimize print quality), and deliver it as a digital file or output an 8 x 10-inch print good enough for reproduction, all in about the time it would take you to mix fresh chemicals.

Recently, I needed one black-and-white illustration for a magazine article. In the past, I would have chosen the negative, set up the developing trays, made a test print, developed it, made a final print, developed it, washed it, dried it, and shipped it out. If that was the only print required that day, or if I couldn't spend more time in the darkroom, I would have had to dump the developer, clean up the darkroom, and so on after making the print.

Instead, I chose an image that had been scanned onto a Photo CD, opened the image's file, made a few contrast adjustments, burned in a "hot" highlight, saved the new image, and pushed the "Print" button. The entire process took about five minutes, beginning to end. If the magazine could have handled an electronic image file, I could have modemed the image over the phone lines, sent them a disk with the image file, or attached the image file to an e-mail, all of which can be downloaded and imported directly into a layout.

The delivered print was as good as any RC (resin-coated) print I could have produced in the darkroom. I didn't waste paper because instead of making a test, I previewed the image on the monitor. I didn't use any chemicals or have to bother with setting up and cleaning the darkroom after the print was made. Of course, this scenario presumes that the image had been digitized beforehand and that the necessary imaging equipment was readily available.

If you already have the equipment for optical-path print-making, you've already made a substantial investment. Indeed, making the switch to digital may seem like a large expenditure on top of money already spent. There's no question that starting from scratch in digital costs money. At a minimum you'll need a computer with enough power to work on images; a CD-ROM drive; a good software program for manipulating images; a companion drive and media for storing images; and a printer that is capable of delivering good-quality prints. You may also want a scanner for digitizing your images, one that works with both prints and film.

The good news is that prices for all these components have come down considerably over the past years and will continue to fall, at least in a price/value ratio. In truth, the cost of setting up a digital darkroom is about the same as that of establishing a well-equipped conventional darkroom. What you can subtract is the cost of plumbing, chemical mixing and storage supplies, sinks, drying racks, and so forth. You can also count on using a lot less room for your digital imaging work space.

This was recently made clear to me when, due to a studio move, I found myself without a darkroom space. For a period of time I had to pack up my enlargers, sinks, etc. and store them in my home, where space is always at a premium. To continue printing I had to rely on friends, a school darkroom, and rental space. Given the time I like to spend during a printing session—just getting warmed up in the darkroom can take a good half hour—this became a real problem. That is when I first began to explore the black-and-white "digital darkroom."

The space required for digital imaging is a tabletop; other than that, all you need is an electrical outlet and a surge suppresser outlet strip. It's all done in room light, without the need for plumbing and temperature-control valves, and there's no need for ventilation, other than making sure the room doesn't get too hot. In short, the digital darkroom is easy to set up, portable, and doesn't require plumbing to function. (At the first opportunity I did set up my darkroom again; I will always return to the conventional darkroom, mainly for the enjoyment it brings.)

Last, but not least is the issue of artistic passion and the visceral sense of involvement, which is often necessary to create a spark in your work. For this, the computer environment may seem less accessible. You are always at a distance from your work, partitioned behind a glass window through which you must gaze and make creative decisions. Working with your image on a monitor is very different from projecting it onto an easel. It's very "hands off" in that sense, even though you do move things around with the keyboard, mouse, or stylus controls. Certain tasks, such as burning and dodging, seem to be less participatory when done with a mouse or stylus rather than when shaping and defining light with your hands. You do not work with water or get to feel the texture and edge of the paper as you process it. And, sadly, you do not get to see the image emerge in the developer. For many photographers, this is disconcerting, as the magic of the darkroom environment is replaced by the rather impersonal computer and monitor screen. Aside from the steep learning curve, this is one of the most difficult adjustments to make.

Computerized imaging does have its benefits, even if it does lack the darkroom's "charm." The ability to experiment is certainly expanded. You can preview the results of your creative decisions immediately without needing to run through the entire printing process. It also offers an entirely new palette of options designed to expand creative possibilities. And you can work more consistently and create scripts that reduce the tedium of the more mundane image-producing tasks. Finally, there's the excitement of working with new tools and techniques, which always brings creative energy to an open mind. You will probably find, as I have, that you will become as "lost" in the creative aspects of digital imaging as you once did in the darkroom.

Digital Images and Imaging Systems

In this chapter we'll explore the elements that make up the digital imaging system and how they compare to conventional photography. We'll also cover what you'll need to set up a digital darkroom, and how to produce a digital image from a photograph.

In order to familiarize you with digital imaging, we'll begin by comparing the photographic to the digital process. The jargon used to describe digital imaging can be confusing at first, but it's just another way of describing the process you must go through from the moment you take a picture to producing the end product you envision.

Computer people like to use the term "imaging chain." The process is usually described as: Image Capture → Image Conversion → Input → Processing and Manipulation → Output Image Management. The translation is as follows:

Digital Jargon	Conventional Equivalent
Image capture	Taking a picture
Image conversion	Developing the film, making a contact sheet
Input	Placing the negative in an enlarger
Processing and Manipulation	Selecting print size, cropping, adjusting contrast, burning, dodging, bleaching, toning, etc.
Output	Making a print
Image Management	Filing negatives in sleeves; storing them with contact sheets; organizing negatives and notes you've made during printing for future reference

The Nature of Film

To better understand how to relate film to digital imaging, let's briefly review the attributes of film. Film is composed of a flexible support coated with an emulsion of light-sensitive silver-halide grains suspended in gelatin. A latent image is recorded by the chemical change these grains undergo when exposed to light. Chemical development "amplifies" the latent image or makes it visible.

The more light an area of the film receives, the greater the density on the negative. This is how the various tonal areas are recorded in direct relation to the brightness values in the scene. Development controls the contrast of the negative image and can be manipulated to yield higher or lower contrast renditions of the scene. In essence, exposure determines density, and development controls contrast.

When magnified, the photographic image is revealed to be composed of silver particles. The distribution of these particles gives the appearance of grain. The placement of the particles is fairly random, and their growth (and thus density) follows the pattern of exposure. The texture, pattern, distribution, and density of the particles are what form the image and in fact what stamp an image as photographic.

Film speed, designated by an ISO number, indicates a film emulsion's relative sensitivity to light and is determined in the manufacturing process. The choice of film speed should be dependent upon the lighting and shooting conditions that prevail at the time of exposure. The general rule of thumb for film selection is that slower speeds yield finer grain, increased sharpness, and less contrast. While film can be pushed to higher effective speeds (called exposure indexes, or EIs), they do suffer some increase in graininess and contrast as a result.

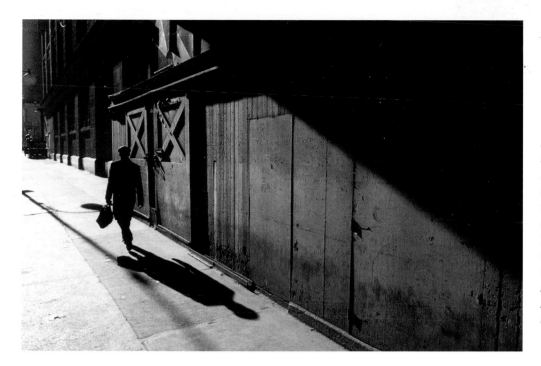

Images originally created on color materials are excellent sources for black-and-white printing in the digital realm. This 35mm slide was scanned onto a Photo CD. All Photo CD scans are RGB, even those that originated from black-and-white images. You can convert the image to black and white by changing the mode to Grayscale (Image > Mode > Grayscale). The system "reads" the luminosity of the pixels that make up the image. The color information is discarded, which greatly reduces the file size. This print, made "straight" from the scan without manipulation except for the mode change, shows every nuance of tone that appeared in the original color slide.

A premium film with an ISO of 25 can be enlarged many times over without loss of image quality. Enlargements up to 16 x 20 inches from 35mm ISO 100 films show minimal image degeneration. Today, films as fast as ISO 400 deliver outstanding image quality, good enough for virtually any end use.

Film and Print Sources for Digital Image Files

Every photographic source, including color negatives, color slides, black-and-white negatives, black-and-white slides, and color or black-and-white prints, can be converted to a digital file. You can photograph the original image with any format you like, but as with conventional photography, a larger-format original yields better quality if your aim is to make large prints.

In both conventional and digital photography, the quality of the original will to a great extent determine the quality of the final result. A large-format negative will yield better results when enlarged than a 35mm negative (given that all other factors are equal), and a properly exposed negative will always be easier to print than a poorly exposed one. While it is true that you can digitally manipulate a source image to optimize it, there is no magic formula for turning a poor original into a high-quality final image. The axiom "garbage in, garbage out" applies, despite the claims of some computer imaging pundits.

The Optimum Photographic Image

There are no special requirements for negatives, slides, or prints to be converted to digital form. In general, a photographic image that will yield good results with conventional techniques will perform the same in digital work. Poor exposure is just as much a problem in digital work as it is in conventional printing. Lack of information due to poor exposure will make your work that much more difficult later.

When working with negative film, follow metering, exposure, and development procedures that yield the maximum tonal range possible. With negative film, err on the side of overexposure if need be, especially in high-contrast lighting conditions. The key is to get the visual information on the negative, then apply corrective procedures in the processing or manipulation stage, just as you would in conventional printing. For those who use a condenser enlarger and therefore may develop black-and-white negatives that are a bit "thin," begin developing your film longer to produce as "straight" and full-toned a negative as possible.

Slide film is much more critical of exposure miscues than negative film. If improperly exposed, slide film will have greater loss of information due to its narrow exposure latitude. Unlike negative film, overexposure with transparency film means loss

of highlight information, not increased density that can be selectively exposed or burned in later. Color slides can be easily converted for use in the digital black-and-white darkroom and, when properly exposed, yield wonderful results.

Prints can also be used as sources for digital images, but because they are derived from a negative or slide, they have a narrower dynamic range than is found in the original negative. There may be times when it becomes necessary to work from a print, for instance, if you have lost or damaged the negative or slide. But in my experience, working from the original film in the digital darkroom is best, because you don't have to contend with tonal compression, the paper surface, or optical brighteners. The handworked print is best used as a proofing master with which to compare results.

When it comes to image quality, the demands of conventional photography should be upheld when working in the digital darkroom. Although some problems with a photographic source image (such as repairing a scratch) may be easier to contend with digitally than conventionally, corrective procedures demand time and effort that distract you from the more creative procedures of image manipulation and enhancement. Starting with a flawless original will allow you to work sooner with more creative techniques.

■ The Nature of the Digital Image

The building blocks of electronic images are called pixels (picture elements). Each is a single point of information recorded by a scanner or digital camera. These picture elements are square or sometimes rectangular, and a digital image is a bit map, or matrix, of adjacent pixels. Image quality is in large part dependent upon the resolution, or number of pixels recorded by the image capture device. Generally, the higher the number of pixels, the better the resolution, tonality, and edge sharpness an image will have. If you magnify an electronic image you will see a grid of these pixels rather than the grains apparent on a film enlargement. This is one characteristic that distinguishes a digital image from a photograph.

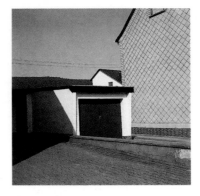

The building block of the digital image is the pixel (short for picture element), a square or rectangular box that contains brightness and color information. In the black-and-white realm a pixel can contain up to 256 levels of gray (including black and white), thus forming, with other pixels, the illusion of tone in an image. Pack those pixels tightly enough, and you get the look of a continuous-tone image. When you over-magnify a digital image, those pixels become manifest, similar to the way grain becomes obvious in over-enlarged photographic images. Here, an image becomes more and more abstract, revealing the pixel structure as it is progressively enlarged.

Resolution

Resolution is very important when images are scanned and printed (input and output). Digital image resolution describes the number of pixels per inch (expressed as ppi) in a scanned image. When you print (output) your image, that term is translated to dpi (dots per inch) and relates to the printer's ability to output an image at a certain resolution. These terms are equivalent; ppi refers to input, while dpi is used for output. Resolution defines both the quality of an image and the limits of how that image can be used.

Film has limitations, and enlarging an image too much affects sharpness and enhances grain, though lens sharpness and exposure density also have an effect. Likewise, low-resolution digital images will also look unsharp when over-enlarged, and

they will also manifest their building blocks—the pixels. This looks quite different than coarse grain; when taken beyond reasonable limits the image will exhibit what in the digital world is called "jaggies"—a stairstepped effect along contrasting edges and the breakup of fine lines into dashes.

You will see how the image resolution has important quality implications. Likewise, when printing, you'll see how your choice of various resolutions affects the possible degree of enlargement. In short, resolution and print size are interdependent. This idea can easily be related to conventional photography by examining the differences between a 5 x 7-inch and a 20 x 24-inch print made from the same 35mm negative. The same relationship exists between image file size and final print size in digital imaging.

The smallest measure of computer data is called a bit, short for binary digit. A binary system uses only two numbers, and a bit can have a value of either 0 or 1. The terms you will be dealing with are bytes—8 bits equal 1 byte; kilobytes (K)—1024 bytes equal 1 kilobyte; megabytes (MB)—1024 kilobytes equal 1 megabyte; and gigabytes (GB)—1024 megabytes equal 1 gigabyte. (The factor 1024 is derived from the fact that in a binary system, calculations are made in base 2; 2^{10} equals 1024.) Image files are often referred to by their file size, expressed as 97 K, 4.5 MB, 18 MB, and so forth. File size for images is determined by the following equations:

For grayscale images:
(Resolution x Image Height*) x (Resolution x Image Width*) x 1
For RGB images:
(Resolution x Image Height*) x (Resolution x Image Width*) x 3
For CMYK images:
(Resolution x Image Height*) x (Resolution x Image Width*) x 4

*Resolution is generally defined in pixels per inch but can also be defined in pixels per centimeters. Be sure to use the corresponding unit of measurement for height and width factors.

Thus, a grayscale image file is one-third the size of an RGB image file, and one-fourth the size of a CMYK image file. As you work with digital imaging, you'll appreciate how large image files can get: a high-resolution color image can easily be a 50 MB file. To understand how much more information is in an image file compared to a text file, the storage space required for this entire book as a word processing document is about one-tenth that required for just one of the image files.

These numbers may seem confusing at first, but they are the signposts that indicate what size file you have and how much you can do with it. They are of vital significance when scanning an image for a particular end use or when choosing which file format to use from a Photo CD.

Bit Depth
To understand the nature of a digital image file you need to understand the term bit depth. In conventional black-and-white photography, levels of gray are created by the various densities of silver deposited on film via exposure and development. Brighter values record with more density; darker values with less. When a positive print is made from the negative these values are reversed to form a rendition of the brightness values of the photographed scene.

As mentioned, computers work on a binary system; each bit of information is represented by a 0 or a 1. Bits are then strung together in groups to represent complex information. To the computer, every character on the keyboard is a specific sequence of 0's and 1's. In a digital image, the color or tone of each pixel is also represented the same way.

Bit depth refers to the number of bits a computer system can assign to each pixel. The more bits per pixel, the more possibilities it has for displaying various shades of gray. In a 1-bit system, there are only two options—the pixel can be 1 or 0, black or white. A 4-bit system offers 16 different 4-digit combinations of 1's and 0's and therefore 16 possible shades of gray. To yield an image with a smooth tonal range requires 256 shades of gray.

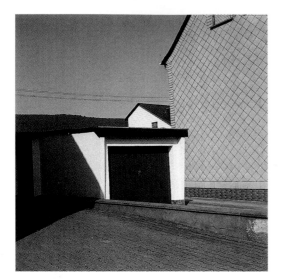

Image A

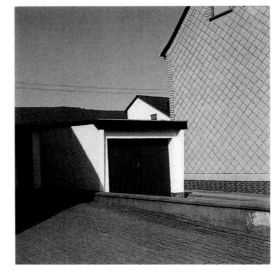

Image B

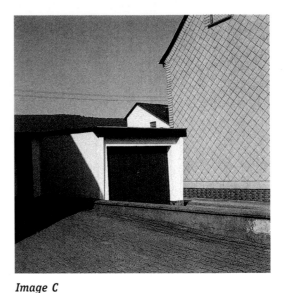

Image C

When you save a file for storage or future reference you have a number of file format choices. You can save the file using a proprietary software format, such as Photoshop. Most of these can be read by outside systems. TIFF (Tagged Image File Format) and EPS (Encapsulated PostScript) formats are probably the most universal image file formats. Check the end use requirements or ask your service bureau which file format they prefer.

You can also compress a file when you save it, which economizes on storage space. The most popular format for compression is JPEG. Be aware that compression may result in less than optimum results when you re-open the compressed file later, especially when working with larger files.

Image A is output from a 968K file saved in Photoshop format, printed out to 6 x 6 inches at 162 ppi resolution. Image B, a JPEG file compressed to 495K, shows little change, but in Image C with a 99K compression, degradation is noticeable, particularly in areas of continuous tone. Experiment with different compression formats and ratios to see how they affect your results. Fearing information loss, many imagers avoid compression and store images at their full file size. Compression may come in handy for smaller output end uses and for sending files via the Internet.

Eight bits per pixel produce those 256 shades of gray. (It should be noted that some digital devices gather information with greater bit samples than eight, but 256 is the magic number in terms of output.)

In conventional color photography, the illusion of color is created by a set of color recording layers in the film. Each color layer captures light and creates density in proportion to the color in the photographed scene. When developed, color dyes replace the silver in proportion to the recorded density, and the resultant "sandwich" yields a full-color image. In developed color negative film the densities and colors are "negative" or reversed in a cyan, magenta, and yellow pattern, which print as a positive red, green,

and blue. This combination forms all the colors in the visible spectrum, at least as far as film is able to reproduce them. In color slide film the reversal takes place during the actual processing of the film, which results in a positive master image.

When working in color, each pixel on the monitor is actually made up of three colored dots—red, green, and blue. Varying the shade of each of these dots colors the individual pixels, and thus, the whole image. For a computer system to display photographic-quality color, it must be able to produce over 16 million color variations (256 shades to the power of 3). This requires 8 bits per color "channel," or 24-bit color.

■ Image Conversion and Storage

To make the transition from film to digital we must convert the so-called "analog" image to digital form. There are a number of ways to do this; you can do it yourself by investing in a scanner, a device that literally scans the image information and converts it to electronic signals. You can also have a service bureau or pro lab do your scanning for you and place them onto a Photo CD or another storage medium.

If you plan to do a lot of computer imaging, you may want to invest in your own scanner. If you just want to experiment or will only be working on select images, it may be more economical to farm the work out. I would suggest the latter course for anyone who's at the exploration phase, as it's a fairly inexpensive way to try out digital imaging. Even experienced computer imagers rely on outside sources to do some of their scanning work. Scanning is a craft unto itself.

All the images in this book are created from Photo CD scans. I chose to work with Photo CDs because they are the lingua franca of digital imaging; they are accepted by either platform, and virtually every imaging program can import images from a Photo CD. Of course, this assumes that you have a CD-ROM drive on your computer system, a matter we'll cover when we discuss hardware.

Ordering Photo CD scans is similar to ordering conventional reprints. Submit your slides or negatives to a service bureau that will scan them onto the Photo CD media. Although black-and-white negatives are put onto Photo CD as RGB scans, don't be concerned, the transfer works just fine. The images in this book were converted chiefly from black-and-white negatives, but quite a few were drawn from black-and-white slides, color slides, and color negatives.

Photo CDs come in two "formats" of use to us here: Master Photo CD only for 35mm images, and Pro Photo CD for 35mm, medium-format, and 4 x 5 film formats. A Master Photo CD can hold up to 100 35mm transparencies, while the Pro version capacity varies quite a bit, depending on the film format and scan size. Photo CD works on an image "hierarchy," which means each image is stored at five different resolutions. Pro Photo CD offers an optional sixth resolution that holds 72 MB of data, seriously limiting the number of images that can be stored on the Photo CD. While the Pro scans cost more, the 72 MB scan offers more options if you later decide to create large prints.

Select the resolution you'll be working with according to the end use for the image. Choose low-resolution "thumbnail" files for filing and retrieval systems and higher resolutions for producing photographic prints. For example, a file size of 128 x 192 pixels (the smallest in the Photo CD hierarchy) is often good enough for image management systems, thumbnail prints, and attaching e-mail, provided it will be viewed on screen. The largest Master Photo CD file size is 2048 x 3072 pixels, an 18 MB file, which yields a beautiful 8 x 10 print. The Pro Photo CD has one additional higher-resolution scan of 4096 x 6144 pixels, which provides an image file of 72 MB. Quite a few prints in this book were made using a 1024 x 1536 pixel, or 4.5 MB, file and the results are very pleasing.

You can manipulate file size via interpolation (or resampling), in which the imaging software creates additional pixels by averaging adjacent "real" pixels in the image. This allows you to get some extra mileage out of a smaller file but is not a cure-all for file size deficiency. It's akin to blowing up a 35mm slide to a 4 x 5 slide; you gain size but do not alter the true character of the image itself.

With every Photo CD scan made you receive back a "contact sheet" of thumbnail-size images. Each time you add more images to the disk a new contact sheet is made. This makes for easy visual retrieval of select images. You can also organize images by using image editing software, which usually takes a low-resolution "snapshot" of the file and places it into an image directory. A host of these filing programs are now on the market.

In some cases you might want larger image files than are available via the Photo CD, such as for big display prints or other high-resolution output. When this is required, use a service bureau that works with a drum scanner. But there is no advantage to having such expensive scans made unless you have a definite need for such large files. The files produced can be much larger than a typical home computer can handle, processing times will be very long, and the printer may not even be able to use the extra information. In essence, it would be akin to using an 8 x 10-inch negative to produce a wallet-size print.

Scanners

If you plan to do a lot of digital imaging, you might consider purchasing a scanner for converting film or prints to digital information. Desktop scanners are available in a number of configurations. Flatbed scanners allow you to transfer both prints and film originals to digital form. Film scanning module options allow you to adapt the unit for scanning negatives and slides. Desktop film scanners that can handle film formats up to 4 x 5 are available. If you're primarily working with 35mm film, there are a number film scanners from which you can choose that are dedicated to that format.

Some scanners come bundled with image processing software that integrates the scanner with your system and controls color, contrast, and resolution. This software can be a real advantage, as it will help you create optimized scans. Although you can usually accomplish the same tasks using other image processing software, starting with the best possible scan saves time and frustration. When choosing a scanner, consider the density range it can capture (higher than 3.0 is best), the dpi it can handle (the maximum resolution should be higher than the output size you need), and the bit depth of the color it can capture (10 or 12 bits per channel is the current standard). Make sure that the figures quoted are not interpolated or at least that the base figures (non-interpolated) meet your needs. Interpolation means that the scanner samples pixels and fills in the rest to get a higher dpi number.

You can scan directly to your hard drive, to a recordable or rewritable CD (CD-R or CD-RW), or to other storage media, including various tape or magneto-optical recording systems. Image files take up lots of space, that is, they create large files that can quickly fill whatever media on which they are stored. It's not advisable to scan directly to the computer's hard drive, except on a temporary, transitional basis.

Working with a Service Bureau

There are times when you will want to work with a service bureau or digital lab to have images scanned or output. This may occur if a project calls for a specialized piece of imaging equipment or requires file sizes larger than you can get from your own scanner or a Photo CD. You may need a specific type of file format, or you may want a print made on a medium not available to you.

For example, if you are making photographic quality 20 x 24-inch digital prints on select fine-art paper, a file size of 70 MB or more is probably required. Such files need to be scanned on a drum scanner, the type used by high-end printers and certain fine-art ateliers. If you are working with a custom digital art printer, they probably will want to do the scans themselves, as they have all the equipment—from scanner to output device—calibrated to deliver optimum results.

As a general rule you should work with a dedicated digital lab, a service bureau, or a photo lab that has a dedicated scanning department. While these scans may be a bit more expensive than those from photofinishers, the difference in quality is well worth the price.

■ The "Direct" Digital Image

There are a host of digital cameras and digital scanning backs that allow you to shoot and download images directly into the digital realm, that is, without converting from photographic to digital form. These include snapshot digital cameras (equivalent to point-and-shoot 35mms), 35mm SLR bodies with digital capture devices, and high-end backs that fit on conventional medium- and large-format cameras.

If you require only low-resolution images, and/or only shoot images to be viewed in electronic form (e.g., on a web site), and/or your prints will never exceed snapshot size, you can get fairly good results from some of the digital snapshot cameras currently available. Generally, these cameras are easy to use with few control options. For better results there are high-end scanning backs for medium- and large-format cameras and digital capture systems integrated with pro-level SLRs. Scanning backs, which offer excellent resolution, albeit with slower "capture" times, are the most expensive option for image capture.

Storage options vary for different types of cameras. Images can be stored in on-board hard drives, which must be cleared when full. Many cameras now use removable flash or memory cards similar to floppy disks. Some can be connected right into your computer to download images as they are taken; high-resolution cameras and scanning backs usually require direct computer connection due to the file sizes produced.

Electronic images are captured by CCDs (Charge-Coupled Devices), an array of light-sensitive elements arranged in a single row or rectangular matrix. The CCD converts light to electrical impulses, which are then converted to voltage and stored in memory. To capture color images, CCDs are usually overlaid with red, green, and blue color filters. Some devices have three CCDs, one for each color. Some devices make three separate exposures, one through each filter. Some devices have filter coatings on individual elements within the array.

Some digital cameras allow you to vary the sensitivity of the capturing device, similar to changing film speeds. This is usually done by varying the amount of "gain" applied to the signal, like turning up the amplifier when listening to the radio. This increase in gain may come with an increase in visual "noise," which photographers can relate to as excessive grain. For the most part, however, digital cameras are limited in their ISO range, with most snapshot and even medium-priced systems coming in at EI 100. Digital cameras made for photojournalism and field work may offer a faster "native" EI.

As of this writing, snapshot digital cameras deliver between 350,000 and 600,000 pixels; higher-end systems may have capture devices that go as high as 1 to 3 million pixels; scanning backs for commercial electronic imaging systems are beginning to offer even greater pixel counts, thus the ability to produce excellent large prints.

■ Film vs. Digital Capture

It would seem that the ability to go "digital direct" is an advantage, as there is no intermediate step necessary to convert from analog (film) to digital information. This is true if your main criteria are speed and efficiency of image delivery, such as in photojournalism and catalog or insurance photography, which require the ability to "drop" an image directly into a document or quickly transmit images electronically.

However, experience shows that film today still offers major advantages as the way to capture original images. To get a sense of why this is so, consider a rough equivalent of pixel translation between film and digital capture devices. It's estimated that a single frame of 35mm color film would be equivalent to 18 million pixels of picture information. A full roll of 36 exposures would take up 648 MB of storage space. This is way beyond what most digital cameras can deliver, certainly any that are as affordable

and portable as a conventional point-and-shoot camera. Also, film comes in various speeds, with even ISO 400 emulsions delivering excellent image quality. You also have a choice of formats, with larger film sizes delivering startling image quality. Even as digital imaging technology evolves, using film is certainly not a detriment to working in the digital realm.

■ Computer and Image Processing Requirements

Many computers today come right out of the box ready for image processing. While we all work under budget constraints, there are a number of key items that should be on your buying checklist. When you become involved with digital imaging you will enter a world of upgrades and sudden revelations that what you thought was good enough just won't handle the tasks at hand. This can get expensive—if you get caught up in the game. It's not unlike realizing that you needed a cold light head rather than a condenser head for your enlarger, that you opted for the 11 x 14-inch easel and now want to make 16 x 20-inch prints, and that the SLR you just purchased has been replaced by a new model with more features.

My advice is to work with what you have, or can afford, until you absolutely need to get something else; you'll know when that happens. You should realize that whatever you buy now will be outmoded in two to three years. But that shouldn't discourage you from getting started; in fact, you can often buy used equipment that, while not state of the art, will certainly allow you to learn much about digital imaging and what you can accomplish with it.

The elements that are key to a digital imaging computer system are processor speed, hard drive capacity, memory (RAM), upgradeability, connectivity, and monitor size and quality. You will also need image processing software, a printer, and a file storage system.

Think of processor speed roughly in terms of the power of the bulb in your enlarger light source. If you work with a very low-wattage bulb, your exposures will take much longer than with a bulb of higher wattage. Computer speed tells you how fast computations will take place and is indicated by the megahertz (MHz) rating of the system. Standard ratings currently range from 75 to more than 300 MHz. The higher the rating, the greater the processing power, and the quicker you will get through tasks.

The hard drive capacity tells you how much information the computer's on-board hard drive can store. Hard drive capacities are continually increasing. Until recently, a 1 gigabyte hard drive was considered a very large storage capacity; today, 4 gigabytes is fairly common. Some of this space will be taken by the operating system and software; other space will be needed for storing files and running programs.

Imaging Power and RAM

RAM (Random Access Memory) is the house in which much of the imaging work is done. It is where data is temporarily held until it is stored in a more permanent place, such as on the hard drive or on a disk. RAM needs power to hold onto data, so when the system is turned off, whatever information was in RAM is gone. That's why saving work as you go is important. RAM is required for both input and output functions and to keep things running. RAM is used for scanning, for printing, and for keeping the image on the monitor.

Virtually every computer today ships with a minimum of 8 MB RAM, but this is not enough to run even basic imaging software. For digital imaging, the minimum amount of memory recommended is 40 MB, with more preferred. Indeed, the more RAM you have, the easier it will be to work on images, so don't be hesitant to upgrade or buy additional RAM when you first purchase your system. Every photographer I know who works on images in a computer environment comes to realize that adding RAM is a wise investment.

Image A

The quality of the paper and the capabilities of the output device or printer have a profound effect upon results. The photographic print (A) made from a black-and-white negative on resin-coated paper reveals excellent sharpness and tonal values.

When an image is output on an inexpensive home inkjet printer at low resolution, the space between the tone dots becomes apparent, and the image looks as if it has been woven. In short, the appearance of continuous tone suffers, although sharpness is quite good. This becomes very apparent when images are output onto standard bond paper (B), but is less so when printed on a substrate specifically dedicated to photographic output (C).

Those who may think that digital imaging output cannot rival conventional photographic prints or that there is a loss of image quality and tonality are mistaken. The image (D) was output on a Kodak XLS 8650 PS dye-sublimation printer at 300 dpi. Digital darkroom work eliminates many of the problems associated with optical path printing (poor alignment of the enlarger, the Callier effect, etc.) and delivers qualities of tone and sharpness equal to photographic prints. True, each type of imaging system has its cachet, but digital imaging can no longer be faulted for delivering less than photographic-quality prints.

Image B

Image C

Image D

This leads us to the idea of system "upgradeability." Even if the computer comes standard with only 8 MB RAM, you can buy RAM upgrades and have them installed before you take the computer home. Make sure that the system allows for such upgrades. The rule of thumb for RAM is that you should have three to five times more than the image file size to properly work the image. This may seem difficult to attain with high-resolution files, but there are several ways to optimize the RAM you do have available. One is to work on layers within the image and then flatten, or merge, them later. Another is to quit all applications except the one you're using. Having other applications open, such as word processing programs or on-line services, requires RAM.

A sure way to optimize RAM for imaging applications is to utilize what's known as "scratch disk" space. When many imaging programs run out of RAM they search the system's hard drive for available space on which to work. To optimize the availability of this memory, you can partition the hard drive and direct your imaging software to this area. Check your computer instruction book on how to set this up. You can also assign a separate hard drive as this scratch space, but that will result in slower processing speeds. While having on-board RAM sufficient to handle your work is ideal, using these backups will sometimes help you avoid the bothersome "out of memory" message, albeit with some slowing of operations. As you work, you may find that some applications use more RAM than others; finding shortcuts or other ways to accomplish the same tasks can help.

■ Peripherals

Your system should also allow for easy connectivity to peripherals, or add-on devices, that you're most likely to need. Some examples of peripherals include scanners, monitors, keyboards, CD and other disk drives, and printers. As mentioned, image files should not be permanently stored on your computer's hard drive, as there simply isn't enough space, and you'll slow your system down. Therefore, the ability to add an external storage drive is important. This is where you will always "write" and store your finished images.

A CD-ROM drive is necessary for working with Photo CDs. Having one installed internally in your computer is highly recommended (and almost standard now), but if necessary you can hook an external drive to your system. CD-R (recordable) and CD-RW (rewritable) drives are becoming increasingly prevalent and affordable. Recordable disks can be written to once, and as the name implies, rewritable disks can be used over and over.

Image Storage

If you go the Photo CD route, keep in mind that this medium is "read only," meaning you cannot save image changes back to the Photo CD. For this you'll need another recording medium. Such storage systems and devices include external hard drives, optical drives, optical arrays, writable CDs, tape drives, and disk drives. New storage systems are always being introduced with higher capacities and faster read-back times. The system you choose depends upon just how much storage space you need.

Luckily, price and competition have made digital storage systems less expensive than ever before—and there are many systems from which to choose. If you plan to have digital images output by an outside source—large prints, negatives, transparencies, etc.—it's always good to check with the lab or service bureau on the type of media from which they can work. Also, check with them on the file formats they prefer—most work from standards such as EPS, TIFF, Photoshop, etc.

Standard magnetic storage systems (as of this writing) include Syquest cartridges of 44, 88, 135, and 230 MB capacity; 100 MB Zip and 1 or 2 gigabyte Jaz drives from Iomega; and 120 MB Imation diskettes. These systems are well within the price range for home and studio imagers. Optical technology includes CD-R and CD-RW (recordable and rewritable) CDs, magneto-optical disks and DVD (Digital Versatile Disk). While initially more expensive than the above-mentioned magnetic disk types, these offer cheaper-by-the-megabyte storage, including 230 MB and 1.3 and 2.6 gigabyte capacity. DVD media holds seven times more data a Photo CD; DVD drives can read your "old" Photo CDs. As demand increases, storage systems with greater capacity become more affordable.

Printers

There are numerous printers available for image output, everything from small proofing printers to enormous roll-fed poster printers. Output quality can range from low-res to photographic. Printer technology continues to play catch-up with user demands, and as the market for the digital darkroom grows, so has the selection and quality of output devices, both for home and professional use. Printer choices include color inkjet, dye sublimation, and electrostatic. Dry silver printers, which print on photographic-type paper, are also available. The printer you use for your text files is not sufficient for imaging; even high-quality laser printers will probably not deliver the desired effect.

The best bet for choosing a printer is to look at the output from various image files and then compare. You can view printers at trade shows, read reviews, or talk with your fellow photographers. If possible, bring an image file (on Photo CD or other standard file storage system) to the vendor and try a few printers before you buy. Also, check out the output specifications of the printer, such as the dpi (dots per inch) and maximum print size.

Resolution is one criterion, but how the printer creates the image may be as important as the dpi it delivers. For example, an inkjet printer lays down color by spraying ink through fine nozzles onto the paper. This results in tiny colored dots that, when viewed from the proper distance, give the illusion of continuous tone; the results can be startling, particularly at high resolutions. But lower-priced inkjet printers do not do a very good job with black-and-white images, as D-max (black) tends to be weak. There also may be some "banding," which shows up as streaks in areas of continuous tone (e.g., sky), in the less-expensive models. High-end models found in commercial labs and some mid-priced inkjet printers now coming onto the market eliminate these problems.

A dye sublimation printer mixes transparent colors and overlays them onto the receiving sheet; this is often done with a three- or four-pass process. Although the dye sublimation printer may offer a lower dpi, the results often have a more photographic look than inkjet or laser jet (toner-based) printers yield. All the prints made for this book were produced with the Kodak 8650 PS dye sublimation printer. The colorized, toned, and many of the monochrome prints were created with the RGB ribbon set on Kodak Ektatherm paper; prints from grayscale images were printed on the same paper using the black ribbon set. The file sizes ranged from 1.5 MB to 18 MB; 4.5 MB files produced beautiful 6 x 8-inch prints.

Paper stock also determines print quality, particularly when working with inkjet and electrostatic (toner) printers. Problems of smearing and streaking can often be attributed to the use of the wrong substrate. There are a host of papers now available for home and studio printing. Use the recommended weight and surface, or experiment until you find a good match. You'll find a wide selection of paper stock at business, stationery, and computer stores; digital imaging labs offer a wide variety of output materials, such as art papers, transparent and translucent plastics, and canvas.

Using a printer requires you to purchase "consumables," akin to photo printing paper and chemicals in conventional darkroom work. Dye sublimation printers require special paper and new ribbons every 100 prints or so, depending upon the model. An inkjet printer can print on less-expensive plain paper (albeit with poorer results than when printed on paper especially made for digital photo prints), but the ink cartridges must be replaced.

One other output option is to convert electronic images to film images. This is done with a device called a film recorder, essentially an electronic printing device that "writes" on film. For example, you can create large negatives from electronic files for contact or mural printing. Service bureaus, high-end digital labs, and prepress houses offer this service.

Monitors

Your choice of monitor is very important. You'll want a fairly high-resolution monitor with at least a 15-inch viewing area; anything smaller will strain your eyes, even though the larger monitors may strain your budget. Monitor specs include screen resolution—640 x 480 dpi is the lowest acceptable; 1024 x 768 is average. A key to purchasing a monitor is to match its resolution with that of your computer's video controller board—unmatched means you will only get the highest common resolution, no matter how high-end the monitor.

■ Software

There are two essential pieces of software for digital imaging—an image editing and manipulating program, and an image database. The former allows you to create all the marvelous image effects described in this book, while the latter allows you to file and retrieve the images. There are many image database programs available. Like all filing and sorting tasks, starting to database your images when you first get involved with digital imaging will save catch-up time later.

The image manipulation software of record is Adobe Photoshop, although other software can be used as well. Virtually every professional photofinisher and service bureau can handle images worked in the Photoshop environment and saved in the Photoshop format. All the images in this book were created in Photoshop, and the terminology used is that of Photoshop.

■ Changing Times

While the individual specifications of hardware and software are important, going into too much detail might mean that whatever is written here will be old news a year down the road. Equipment prices, specifications, and capabilities seem to change every six months, as do the modes of storage and availability of new technology. Five years ago, the systems that are now common were out of reach for home use; ten years ago only large corporations could afford what most desktop systems consider to be run-of-the-mill capabilities today. Our expectations of quality are constantly being upgraded as printers available for home and studio black-and-white imaging continue to improve.

Use this discussion on equipment as a basis for understanding what's required, and then to talk with other digital imagers and read up on current specs. In short, your system should have a fairly fast computer with a CD drive, a storage system, image processing software, and a printer. In a few years small, powerful storage devices and disks will hold more information than you thought possible, and image files will have structures that make the current struggles with file size and RAM seem nonsensical. But that's the nature of this technology; change is the name of the game.

Now that we've defined some terms, let's prepare to work. These preparations can be compared to setting up a conventional darkroom, where aligning the enlarger, setting up exposure and contrast grade probes, picking a light source and paper, and choosing the correct lens and bellows extension are all part of the game. The first task in digital imaging is to calibrate your monitor so that what you see on the screen is what you will actually get on a print or output file.

Once your monitor is calibrated, you probably won't need to make more than slight modifications as you work. If you're doing all your output (printing) in your home or studio, the setup can be easily tweaked by comparing your results with what you hoped to get. If you are sending files out to a printer or publisher, send a sample for them to output, and calibrate your system accordingly. This will save you many headaches later.

■ Monitor Calibration

Monitors display an image by projecting light onto a screen in an RGB (Red-Green-Blue) color scheme and can vary in the way that black-and-white contrast and tonality are displayed. Simply put—the image you see on your monitor may not always be what you get on a print or other output. Thus, calibrating the monitor so that your screen image and the printed image will match is key. Happily, many printers come with software dedicated to help you do just that. They link up or have a handshake agreement with your computer. The same linkage is necessary for scanners, which usually have similar software. Today's systems have a standardized way of working that builds "profiles" for output devices.

As black-and-white imagers, we have fewer calibration headaches than those who work in color. Our struggle is more with contrast and tonality than with the stickier issues of color management. We do, however, work with color when creating toned or colorized black-and-white images. Insuring that the screen contrast and tonal rendition matches that of the final print is of utmost importance.

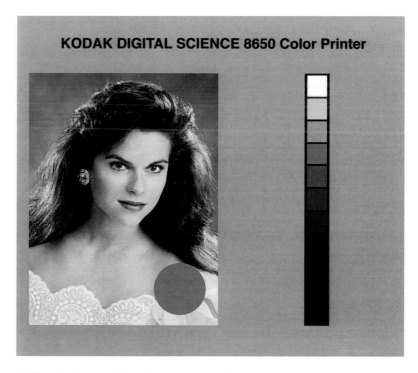

Calibration insures that what you see on the monitor is what you will get from your printer. Test strips or sample files are supplied by printer and software manufacturers to make this task easier. A typical test print, such as this one supplied with a Kodak 8650 PS printer, displays a gray scale, test subject, and gray patch. This can be used as a visual aid or densities can be measured with monitor calibration equipment. Calibrating your system will save you time, money, and frustration as you work.

Every imaging program you work with should have a setup protocol that insures that the image and the monitor match in terms of contrast and tonal range. This may involve setting black and white points and setting the Target Gamma for different output devices. Check your monitor, system, or software instructions for monitor setup specifications. Once these settings are made, you probably won't have to adjust them unless you change the lighting conditions on your monitor or the device to which you're sending the information. Many printers have test strips or test images that can be used to calibrate monitors as well.

Monitor calibration can be tricky, and visual comparison between the print and the monitor is the best way to get everything in line. You may find that a lot of trial-and-error testing is necessary, but as you work, you'll find that time and practice will get you closer to what's called WYSIWYG (What You See Is What You Get) results. In short, when your monitor mirrors what each output device delivers, you'll save time, money, and energy. Having to continuously tweak results or guess how each adjustment will affect the final print job is costly and frustrating.

■ Input and Output Specs

Creating digital files can expand your horizons. As with conventional photography, the final product of black-and-white work might be a print. You might also produce work to be viewed on the World Wide Web or printed directly from a digital file as an illustration in a book or magazine.

When printing in a conventional darkroom, you go through certain steps to insure optimum results, such as matching format and print size for optimum sharpness, choosing an enlarging lens of the correct focal length, and making sure that over-magnification or excessive grain do not impede the visual experience. Some of the controls and requirements differ in the digital darkroom, thus an awareness of what it takes to prep an image for the best results is important. To begin with, you should know the end use for an image—how large it will ultimately be printed or what file size is required—before you begin to work on it. This determines the type of scan required or the resolution level you choose from the Photo CD. These considerations bring us into the world of input, image size, resolution, and output.

The key figure in all this is the image resolution, which is expressed as the number of pixels per inch (ppi). Resolution determines how sharply defined an image is, and it is determined by two factors: the size of the image and the number of pixels per inch. A 1 x 1-inch image with a resolution of 80 ppi contains 6400 pixels, while the same size image at a resolution of 100 ppi has a higher pixel count (10,000), therefore, smaller pixels and higher resolution. This higher pixel count within the same area yields greater image detail and improved tonal transitions. (Think in terms of 35mm vs. 4 x 5 format.) Therefore, a higher resolution means a greater amount of useful image information.

The resolution required depends upon the end use of the image. For example, images for use on a web page don't require the same resolution as images for display prints. If you use the resolution chosen for the web page image to make an 8 x 10-inch print, you'll be sorely disappointed. (Think of making a wallet-size print from a 110-format negative, and then using that same negative for a 16 x 20 print.)

You can always resample to increase resolution by decreasing the image size. As you'll see, it's best to stay within the parameters that yield optimum results and to scan so that no resampling is necessary. For example, the highest resolution on a Kodak Master Photo CD can yield an excellent 8 x 10-inch print; the largest file on the Kodak Pro Photo CD can be output as large as 16 x 20 inches.

Resolution and output size are interrelated. This Photo CD scan of a medium-format, black-and-white negative yielded a 72 MB file size, which when cropped and converted to grayscale mode became a 15.9 MB file. Prints were output on a 300 dpi printer.

Images A1, A2, and A3 were created from a small section of a 40 x 40-inch image.

Image A1

The resolution of this image is 100 ppi. Edges are unsharp, though tonal rendition is not bad. Lack of sharpness makes the image quality unacceptable.

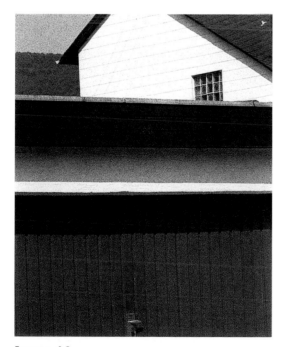

Image A2

The Unsharp Mask filter was applied at settings of Amount: 200%, Radius: 1, Threhold: 0. The edges of the image pick up much more definition, and contrast is crisper; as a consequence, grain increases quite a bit.

Image A3

For this image, the file was resampled to yield a 300 ppi resolution, resulting in a very large image file of 143 MB. Resampling fills in the space between pixels by an algorithm that samples and averages tonality and creates picture information. This image is sharper than the 100 ppi rendition with more apparent grain and a slight increase in contrast.

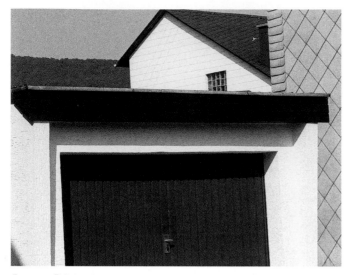

Image B1

Images B1 and B2 were created from a small section of a 27 x 27-inch image.

Without resampling, this image size yields a 150 ppi resolution. Here, the Unsharp Mask filter (Amount: 200%) was applied. Grain, though still apparent, is diminished, and the image has good edge sharpness. The full-size 27 x 27-inch print would be acceptable when viewed from the proper distance (the diagonal measurement of the print).

Image B2

Here, the image was resampled from 150 ppi to 300 ppi, which yielded a 62 MB file. Resampling made the grain more apparent and increased contrast slightly, but edge detail and image definition was slightly improved. Thus, resampling helps to improve output, however it does not cure insufficient resolution entirely.

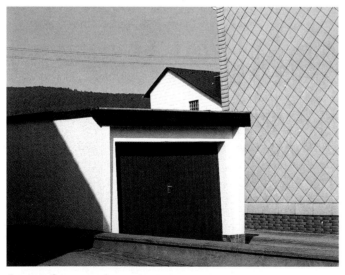

Image C

This print was created from a small section of a 13 x 13-inch image. At this size, the resolution is 300 ppi, which is appropriate for the printer. Grain, contrast, sharpness, and detail are excellent. We can conclude from this that any print size from 11 x 14 to 14 x 17 inches can be made from this 15 MB file without sacrificing quality.

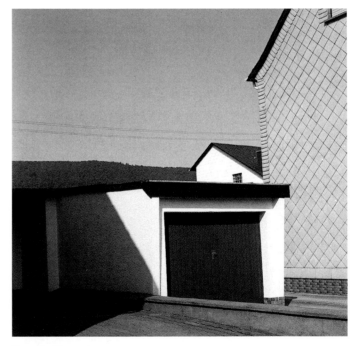

Image D

This is an 8 x 8-inch print of the full image. At this size the scan yielded a resolution of 508 ppi (beyond the printer's capability). Grain, sharpness, and detail are superb.

A common misconception is that you should always go for the highest resolution possible. Not true. Output devices have a maximum resolution they can handle; deliver too much and you're wasting resolution and storage space, and you're substantially increasing output time. The output device will, in essence, toss away the resolution it can't use. Use a 24 MB file on your web site and the download time will be excruciatingly slow, causing most people to quit out of the image before they see even a portion of it.

In addition to the terms that define resolution and output, ppi (pixels per inch) and dpi (dots per inch), there is one other term you may encounter, lpi, or lines per inch. Lines per inch is a term used by commercial printers. It refers to the line screen used to print images in newspapers, brochures, magazines, and other publications. When submitting electronic image files for such projects, check with the printer or publisher as to the line screen they'll be using to print. It will differ according to the medium: magazines typically print using a 150 line screen, very high-end brochures may use a higher line screen, and newspapers will use a lower one.

Usually the resolution of your file should be twice the line screen. For example, if a magazine is printing with a 150 lpi screen, you should provide them with an image that has a resolution of 300 dpi. You may be able to use a file that is larger by a factor of only 1.75, but that often depends upon the characteristics of the image.

Thus, when you input images using a scanner or choose a resolution level from your images on Photo CD, keep the end use of the image in mind and choose the resolution accordingly. If you are printing at home, test to see what size file will produce good results at various print image sizes.

Check the specs on your home or studio printer to find its maximum output, and keep in mind that using an image that is too high in resolution will only cause your file to take longer to print with no corresponding increase in quality. Do the same for high-end printers found in commercial labs. For example, the Kodak 8650 printer that was used to output the illustrations in this book has a resolution of 300 dpi. We made very satisfactory prints using resolutions between 150 and 300 dpi.

If you will be having very large prints made by a commercial lab or service bureau, check with them before submitting any files. In some cases you may not be able to produce a file size that is large enough for the job. In that case, submit the image for scanning along with a small-scale, high-quality proof print to match. They will probably make the scans with a drum scanner, which can yield very large file sizes.

Most image processing programs will tell you the image resolution and file size, and will offer an easy way to change the output size (the print size you want). If you are making your own prints, the software will read the file size, then you enter the desired print size; the program will inform you of the resultant resolution. If, from your tests, you determine that the resolution is acceptable, go ahead and print. If it is not acceptable, you must either reduce the print size until you reach the desired resolution, resample the image to bring it closer into spec (more on that shortly), or rescan the image at a higher resolution.

To repeat, this is the first step in setting up your image for whatever end use you have in mind and is crucial to getting good results. Consult your printer guidelines (or those supplied by your lab) to insure that the resolution required is in line with the file size you choose or create.

If you cannot fulfill these requirements, you can to a certain extent change the image specifications. This process, called resampling, uses something called interpolation to change the relationship between resolution, print dimensions, and file size. If you increase the file size (number of pixels) in order to get a larger final print, the program will "fill in the blanks" using information from adjacent pixels. This will degrade the image somewhat, though the degree to which you resample will determine just how much degradation takes place.

The scan from which you work has a profound effect upon the size and quality of the print you can successfully obtain. Each of these print examples was output at 8 x 8 inches.

Image A

A 72 ppi resolution scan yields a hopelessly unsharp image filled with jaggies.

Image B

Resampled to 300 ppi, the 1.13 MB file becomes a 5.4 MB file. Add 150% sharpening and there is considerable improvement, but the image still appears unsharp and edges are jagged. Note the broken lines in the telephone wires.

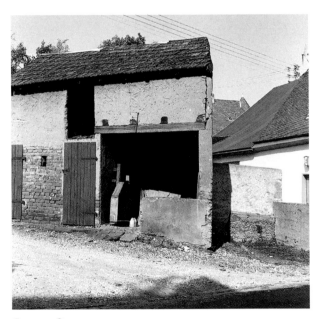

Image C

A very good print can be made from a 255 ppi scan (3.98 MB file) with 150% sharpening.

Even though resampling the 1.13 MB scan yields a larger working file size than our 3.98 MB scan and the pixel resolution is apparently higher, there's no comparison in print quality. Scanning for the desired print size yields better results than resampling the image.

Image A

Image B

■ Tonal Scale

The goal of most printers is to create images with as full a tonal scale as possible and to recreate the contrast and brightness values of the original scene. Of course, there are times when the image may be enhanced by working with other tonal variations (high and low key), or by working in high or low contrast. These judgments are dependent upon how the applied techniques serve visual communication. As with any form of imaging, interpretation is the privilege of the creator.

Photographers who make black-and-white images often relate to tonal values in terms of the zone system, a way of visualizing the gray scale in ten steps, from black to white. This has proven to be an effective method of manipulating exposure and development for both critical tonal control and interpretive imaging. The system takes into account the exposure latitude of film and the ability of the photographer to place certain scene values in respective zones; by manipulating the exposure and development of the negative the tonal range can be maximized

for the lighting conditions at hand, and tonal rendition can be enhanced to yield the best possible range.

Currently, computers can display 256 shades of gray (black and white included). Every pixel can have a brightness (tonal) value ranging from 0 (black) to 255 (white); every point in between refers to a different shade of gray. Because much of what we do is related to printing, grayscale values are also represented as percentages of black ink coverage, with 0% equal to white (no ink on the paper, or paper base) and 100% equal to black (total coverage).

When working with black-and-white images in the digital darkroom there are numerous ways to handle tonality, contrast, and brightness. You can work with white and black point settings; adjust subtle midtones; change the curve to affect the tonal balance of the image; adjust brightness and contrast; burn and dodge; selectively reduce values; add tone through color; and many other options. While the degree of control you can exer-

cise is exhilarating, it can also be confusing and intimidating. The best bet is to start with one control, learn it, and then move on to others. We'll review these controls at the beginning of the workshop section; the bulk of this book is dedicated to their applications.

■ Interpretation and Technique

As you begin to work in this environment you will get a feel for its capabilities; you'll soon realize that the possibilities are open-ended. The tendency at first is to try everything, to apply multiple adjustments, to play with special effects that are very different than you might have achieved or even aimed for in the conventional darkroom. It will show you the amazing number of tools you have at hand. As you gain familiarity, however, my advice is that you refine and simplify your approach and not apply effects for their own sake. The early years of computer-derived images yielded some fairly awful work—more trick than technique, more an inventory of special effects than artistic statement.

The thought process you use to establish the goals for your images should follow the same regimen that you use in any craft—the technique should make for more effective visual communication and not be done for the sake of technique alone. Thus, the interpretation and subsequent manipulation of the image should stem from a contemplation of how the effects better communicate your thoughts and feelings about the subject depicted.

In many cases, that will mean taking a "straight" printing approach. Here, it's a matter of learning the basic tools of image control—contrast adjustment, burning and dodging, highlight adjustment, cropping, minor retouching, and achieving a good tonal spread. In other cases you might want to enhance the print for a moodier, more emotional interpretation. This might call for using diffusion, a high- or low-key approach, special lighting

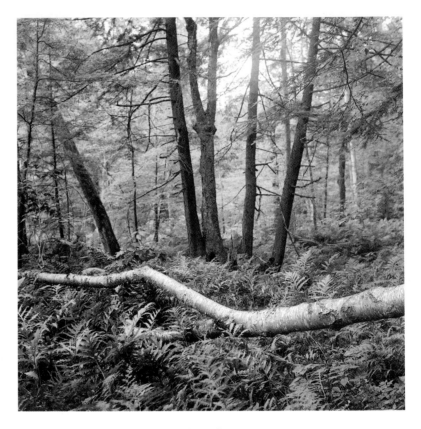

The unmanipulated image printed too flat.

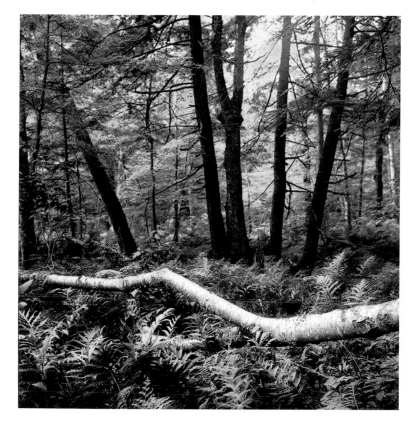

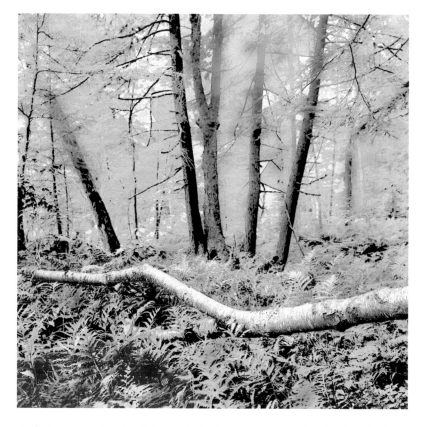

To increase contrast, several different tonal and contrast controls were applied. First, the fallen tree was selected using the Lasso tool, then the selection was inverted making the entire image except the fallen tree active. The active area was darkened through the use of the controls in the Levels dialog box. The tree trunks and branches in the background were made darker through careful use of the Burn tool. Tone was added to the sky by selecting areas with the Magic Wand tool and filling the selections with a shade of gray picked from the Color palette.

Isolating one subject within a colorized scene can add visual interest. Here, the fallen tree was selected using the Lasso tool. The Inverse command was then applied so that changes made to the image affected every area except the tree. Colors were chosen from the Color palette and added using the Paint Bucket tool. After color was added, the Burn tool was used to selectively darken the trees in the background and certain ferns and plants in the foreground.

effects, high contrast, or manipulating the texture or "grain" of the image. Special effects can also be used to create photo illustrations; solarization, bas relief, toning, colorization, and vignetting are all valid when applied to the right image for a particular end use. In each of these cases, attaining what might have taken hours of experimentation in the darkroom can be done with near push-button ease.

■ Color

Most conventional black-and-white papers are not neutral; individual brands usually exhibit an inherent color characteristic that affects the image. Papers can exhibit tendencies toward subtle green, warm brown, or even blue-black. Developing those papers in warm- or cold-tone developers may enhance or neutralize their color in the final image. Chemical toning is used in conventional printing for both archival and color purposes. Common toners in the darkroom include selenium, sepia, brown, and blue. Additional color shades can be obtained by bathing the processed print in various dyes and colorizers.

Effects similar to the conventional ones mentioned are possible when working in the computer realm. You can mix very subtle colors that give a slight tint to the image, thus removing the neutral and sometimes flat look of a strictly monochrome rendition. The look of various toners and dyes can be duplicated. (These techniques are covered in the workshop section.)

■ Film Formats

If you view two 16 x 20-inch prints of the same image made in a darkroom, one from a 35mm negative and one from a 4 x 5 negative, differences in sharpness, tonal fidelity, and detail make it easy to tell the two images apart. The same holds true in the computer realm. The larger the original film size, the greater the gain in ppi, thus the better the image resolution, just as there is better resolution when you make an enlargement from a large-format rather than a 35mm negative. If you're having images scanned to Photo CD and need top quality for larger print sizes, opt for the Kodak Pro Photo CD's additional sixth resolution, a 72 MB file. When scanning with your own film scanner, always keep the final image size in mind.

■ Previews

The beauty of working in the computer realm is that you can preview your options prior to applying any effect to an image. This will free up your experimental spirit and allow you to test options as you work. Compare this to the often mysterious waits you must endure to see if your efforts in making conventional prints have borne fruit, and you'll discover one of the true benefits of digital imaging. Previews of the whole or select parts of the image should be made prior to saving the changes you have wrought. Previewing as you go and then saving only after you like what you see is highly recommended.

You can also make copies of an image file or use the Save As command to make new files that incorporate your changes and still retain the last saved version of the image. You can also work with Layers (in a sense, copies) by simply dragging the background image in the Layers palette to the copy icon at the bottom of the palette. Photoshop also has a New Adjustment Layer. This allows you to apply manipulations and see their effect and then either delete the layer or merge it with the rest of the image.

This book is not intended to replace the users' guide of any image processing program. Reading through the software instructions and working through the supplied tutorials is a responsibility you must take. There are, however, certain key controls used throughout the workshop section that bear explanation. While describing these here should be useful, the only way for you to truly learn about them is by applying them to your images.

The program used to carry out the work shown in this book is Adobe Photoshop. Photoshop is probably the best-known image manipulation software—a standard in the industry. Descriptions and processes may well be applied to other image manipulation and editing programs. If you do not work with Photoshop, you should be able to benefit from the processes described by applying them to your image processing software. Please consult your software instruction book and tutorials for more details.

The "command chain" throughout this section is indicated by the ">" mark. For example, in order to change a color image to black and white we indicate the path of actions as: Image > Mode > Grayscale, which means that one should first choose Image from the menu bar, Mode from the submenu, and Grayscale from the options.

The Menu bar atop the opened program is your key to image adjustments, selections, and special effects. The tool bar that opens along the side of the screen gives you access to the tools of image adjustment. To bring an image into the software, select File > Open, and then choose from the available files. Check your manual for guidelines on how to access files from specific image sources.

The Mode menu allows you to change from RGB mode to Grayscale, Duotone, Indexed Color, Bitmap, CMYK, Lab Color, or Multichannel. All Photo CD images, even black-and-white originals, are scanned as RGB—Red, Green, Blue. Converting a file to Grayscale mode before you begin working it saves time and storage space.

■ Image > Mode

Let's begin with the menu bar atop the screen. The Image menu will be used a great deal. The first submenu to check out is Mode, which allows you to choose from eight image mode options. You'll notice a check mark next to whatever mode you're in. By clicking on one of the options, you can convert the image to whatever mode you desire. Throughout the workshop section, this command is used often to convert an RGB file to a Grayscale file. (You will be asked if it's OK to discard color information; if you do not want to lose a color version of the image, use the Save As command and work on the saved copy of the file.) To duplicate the look of conventionally toned images, the Duotone mode is employed. (You can convert to Duotone only from Grayscale mode.) To print duotone selections, change from Duotone to RGB or CMYK.

The Adjust menu is very important for basic and advanced image manipulation techniques. Here is where you access tonal controls such as Levels, Curves, Brightness/Contrast, and Posterize.

The Levels dialog box (opened via Image > Adjust > Levels) is invaluable for image manipulation. Much of the contrast and tonal controls discussed in this book are accomplished using the Levels controls. The histogram, or graphic representation of the tonal spread, reads black to white from left to right. The sliders underneath the histogram can be moved to shift the black, white, and middle gray points; the Eyedroppers can be used to pick those points as well. All the adjustments you make can be previewed on the screen as you work.

■ Image > Adjust

Under the Image menu is the Adjust submenu. Adjust gives you access to Levels, one of the most important controls in black-and-white printing. When you choose Levels, a dialog box appears. The box shows a histogram, a visual representation of the distribution of tones in the image. Along the bottom of the histogram are three sliders that can be moved to set the image's white point and black point and to adjust the middle gray values. These tools alone unleash a tremendous amount of tonal and contrast control power over an image.

For example, if you want to increase contrast, drag the white point slider toward the center; this lightens the image and increases contrast in the highlight areas. You can set the black and white points at either end of the bar (settings of 0 and 255 respectively). You can also adjust an image according to the histogram by placing the black and white sliders at the initial point of tonal indication in the chart, then moving the grayscale slider to suit your taste.

Equally important within the Levels dialog box are the black, gray, and white point selectors, indicated by the three eyedroppers on the screen. These allow you to pick key tones within the image and assign to them a value. These can be used for making very quick adjustments. All you need to do is click on one of the eyedroppers, then click on the tone within the image to which you want to assign that value.

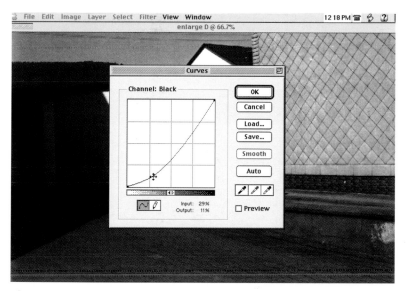

The Curves dialog box allows you to adjust tonal values in an image by adjusting the shape of the curve. You can fix or anchor points on the curve as you work. The three Eyedroppers allow you to pick and set white, black, and gray level points in the image. Click on the Eyedropper in the dialog box, then click on a selected tonal value within the image, and it will change accordingly. The white point sets the brightest white; the black point sets the deepest black. The gray point Eyedropper is an excellent tool for making quick image contrast adjustments.

Another image control option under the Adjust submenu is Curves. I rely on Levels chiefly for tonal and contrast adjustments and use Curves for more creative options and special effects. Curves also has eyedroppers for white, black, and gray pinpoint control.

Other options in the Adjust submenu include:

Brightness/Contrast: Use this command to make a quick fix on an image, though Levels gives you more control.

Hue/Saturation: This is used when you want to colorize an image or add an overall wash of color. This also allows you to pick and apply specific colors from the color palette, plus it gives you control over contrast and brightness.

Desaturate: Converts a color image to black-and-white without deleting the color information.

Invert: Choose this command to convert a positive image to a negative (or vice versa). Each pixel in a black-and-white image will be replaced with its tonal value opposite.

Equalize: This option really digs into an image and redistributes the light and dark values, so you can see all the potential an image contains. If you have an image that is too dark or lacks contrast, this command will often reveal detail that may have previously been obscured.

Threshold: This command makes a high-contrast image by converting values to either black or white. Use the slider under the histogram or enter a number in the Threshold Level field to set the "breaking" value point. Tones above this value become white, tones below it become black.

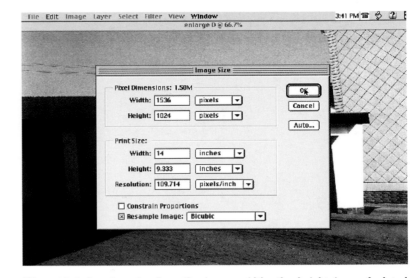

The Image Size dialog box, opened by choosing Image Size from the Image menu, is where image output calculations are made. An image with a 4.5 MB file size is approximately 21 x 14 inches at 72 ppi (screen resolution).

When 14 inches is entered as the image width, the height is recalculated to 9.333 inches to constrain proportions and the resolution increases to 109.714 dpi.

■ Image > Image Size

The Image Size dialog box is used to select the size and the resolution at which your image will print. The current file size and dimensions are listed as Pixel Dimensions in the dialog box. Under the heading Print Size, you can alter the image size and resolution. There are two check boxes at the bottom of the dialog box, Constrain Proportions and Resample Image. If you change the size of the image in one dimension, the other dimension is automatically calculated if Constrain Proportions is checked. If Resample Image is checked, you can change the image resolution without changing the dimensions. The default settings are Constrain Proportions checked, Resample Image unchecked.

If you would like to make a print of a particular size, type those dimensions into the Print Size width and height boxes. This will adjust the resolution correspondingly, and if the resolution is satisfactory, you're in business. For example, say your current file is 8 x 10 inches at a resolution of 72 ppi. But you want to make a 4 x 5-inch print. When you plug in 4 and 5 inches as the dimensions, the resolution becomes 144 ppi. If this is satisfactory, click on the OK box, and the computer will resize the image file. You can also type in a desired resolution and see the corresponding change in print size, or you can resample the image to bring it down (or up) to your specifications. Just remember, resampling to a higher resolution will degrade image quality.

In an attempt to raise resolution, you can reduce the dimensions, but the print size may become too small. To increase resolution at a larger print size, check the Resample Image box and type in the required size and resolution. At 9 x 14 inches this 4.5 MB file was only 109.714 dpi. It was resampled up to 300 dpi. Note that what was a 4.5 MB file becomes a 33.7 MB file due to the addition of pixels by the software. Resampling to a higher resolution is not an ideal solution as it degrades image quality. Scanning the image at the size needed is always preferable. If you must resample an image, an output test should be done to determine whether resampling will yield satisfactory results.

The Filter menu opens the door to a host of image correction and special effects tools. The first item listed on the Filter menu is the filter that was last applied. In this example, it is Unsharp Mask. The Sharpen filters are used quite often throughout this book's workshop section.

■ Filter

The Filter menu is your entry into the world of special effects. There are quite a few that can be used effectively in black-and-white imaging, but overuse can become tiresome. Many of the filters have dialog boxes that allow you to change the degree of effect and to preview any adjustments. Some filters take quite a while to be applied, so give yourself time to browse through the various options. Filter programs, known as plug-ins, are also available from third-party suppliers; these expand on the full array of options that come standard with Photoshop and other software.

Sharpening: Some blurring may occur when images are scanned or resampled. For this reason, it is often a good idea to apply some sharpening to images. There are four filters for sharpening, but the the one I find most useful is Unsharp Mask (Filter > Sharpen > Unsharp Mask). This filter counteracts the tendency of some scans to soften "edges" (where two adjacent pixels are of different enough color or tone to form contrast). Despite its name, the Unsharp Mask filter can add sharpness to slightly soft images. This filter's dialog box allows you to set the Amount of sharpening (expressed as the percentage you want contrast to be increased between pixels), the Radius (the number of pixels to be altered surrounding each pixel that makes an "edge"), and the Threshold (the setting at which pixels are considered to have enough contrast to form an "edge"; e.g., at 0 every pixel qualifies for sharpening). Use the preview box to see how contrast and "grain" are increased and to determine when too much sharpening may actually degrade the visual appearance.

There are some subjects you may not want to sharpen, including portraits and some landscape images. You can use the Threshold setting with Amount set to 0% (i.e., 0 sharpening) to soften what might otherwise be a harsh rendition of a portrait subject. This effect is similar to using a diffusion filter over a lens.

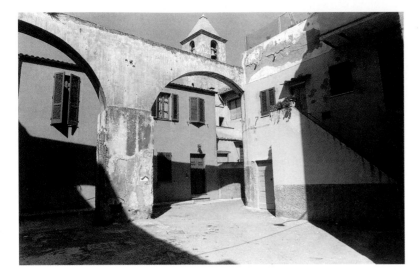

This very clear 300 ppi image was created with Unsharp Mask settings at Amount: 150%, Radius: 1, and Threshold: 0. This image would satisfy most needs.

To see the effect of increasing the Amount and Radius settings, the Amount was 150% but the Radius was changed to 20. Edge sharpness increased considerably and there was some increase in contrast.

The filter was applied again at the same settings. As the effect is cumulative, the contrast increased considerably. The image is tack sharp, but certainly has begun to lose tonal integrity.

After the filter was applied again, the accumulation of the effect resulted in an image with all the charm of a print from an office copy machine.

Virtually every image with which you work can benefit from some degree of sharpening, especially when you're working from Photo CD scans. In Photoshop you can use the generalized Sharpen commands, but this affords considerably less control. My preference is Unsharp Mask. (The term is somewhat confusing; the filter masks unsharpness to sharpen the image.) This command offers three controls: Amount (the increase in contrast between pixels, expressed as a percentage); Radius (the number of pixels surrounding contrasting edges

that will be sharpened); and Threshold (the amount of contrast an area must have to be affected; 0 is the default setting, higher settings "dampen" the effect somewhat.)

Not every image should be sharpened. Sometimes, only the Threshold should be set. For example, portraits, closeups, and some scenics benefit from 0% sharpening with a higher Threshold setting. It is recommended that most portraits be set at a Threshold of between 2 and 20.

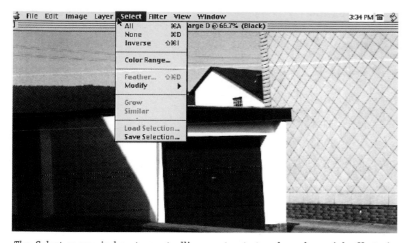

The Select menu is key to controlling contrast, tonal, and special effects in selected areas. It offers the selection options All, None, and Inverse. This menu also includes the Feather command, which determines the pixel spread of tonal borders.

The View menu is used to display various aspects of the image and to zoom in and out for closer examination of portions of the image.

■ Select

The Select menu is extremely useful when you are working with discrete parts of an image or to mimic the effects of "split-contrast" printing. After you make a selection (more on that soon) you can change the selection to the remainder of the image by choosing Select > Inverse; you can then revert back to the selected portion of the image by inverting the selection again. This ability to toggle between selections is invaluable.

When you need to select the entire image, use the Select > All command; it is much easier than using one of the selection tools. If you want to eliminate all selections, choose Select > None.

■ View

Use this menu to choose various ways to view your image. When you have an image open, the New View command opens a second window with the same image. You can hide and show guides, rulers, and edges (selection marquees). You can enlarge or reduce an image within its window with the Zoom In and Zoom Out commands.

■ Window

Open the Window menu and a number of options appear that allow you to show or hide the various modification, color, and adjustment controls and palettes on your screen. These dialog boxes (those that call for a response on your part) and palettes include the color swatches and brush sizes.

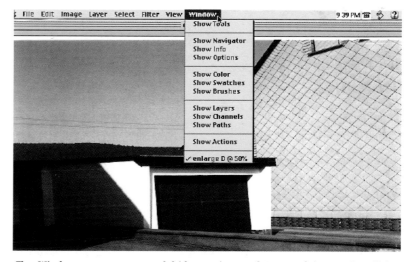

The Window menu opens and hides various palettes and interactive dialog boxes. You can change the brush sizes on paint tools, choose colors or tones, and open the various palettes, such as Layers, Paths, and Channels.

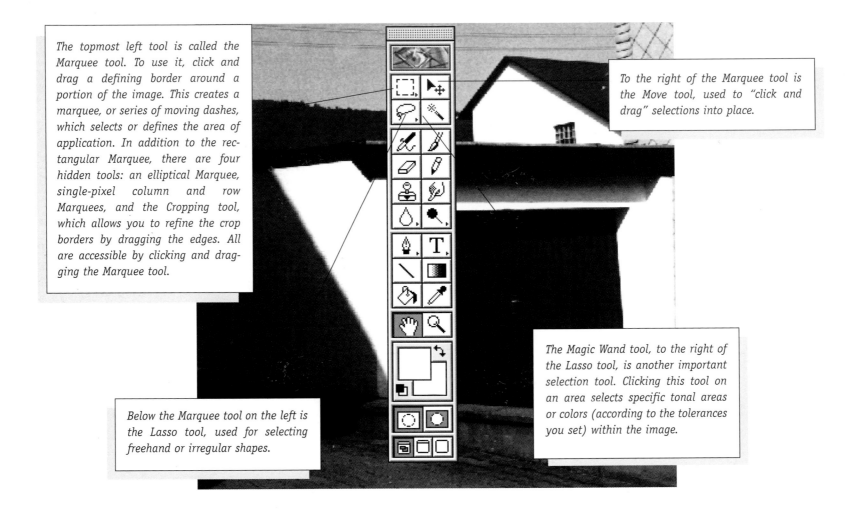

The topmost left tool is called the Marquee tool. To use it, click and drag a defining border around a portion of the image. This creates a marquee, or series of moving dashes, which selects or defines the area of application. In addition to the rectangular Marquee, there are four hidden tools: an elliptical Marquee, single-pixel column and row Marquees, and the Cropping tool, which allows you to refine the crop borders by dragging the edges. All are accessible by clicking and dragging the Marquee tool.

To the right of the Marquee tool is the Move tool, used to "click and drag" selections into place.

The Magic Wand tool, to the right of the Lasso tool, is another important selection tool. Clicking this tool on an area selects specific tonal areas or colors (according to the tolerances you set) within the image.

Below the Marquee tool on the left is the Lasso tool, used for selecting freehand or irregular shapes.

■ The Toolbox

The Toolbox is where you choose various image-modification items—think of it as the source for print controls. A single click on any tool brings it into play; a double-click evokes a dialog box that allows you to modify the tool and choose various options. If a tool has a sideways T symbol in the lower right corner, click and drag on the tool, or hold the Option key and click on it, to see other tools that occupy the same box. Many of the tools have palettes or interactive areas that allow you to define and refine their uses. A discussion of some of the tools and their various applications in image creation follows.

Cropping: When you want to crop, Option-click on the Marquee tool to open the Crop tool. Drag with the mouse to create a selection, and then refine that selection by dragging the edges of the frame accordingly. You can also crop using the Marquee tool to create borders, then use the menu command Image > Crop, and hit Enter or Return to make the crop. You'll notice that cropping the image reduces the file size. Cropping with the Marquee tool gives you more shape options. We suggest that you crop out any black space that appears around your scanned image; it will show up on Photo CD scans of square-format images. This black border takes up file space and is unnecessary for any image manipulation.

Selection: Selection tools are used to choose a portion of an image—for instance a face in a portrait, the sky in a landscape, or a pair of eyes. When a selection is made, a moving series of dashes, called a marquee, appears around the area. This selection then becomes "active," meaning effects will be applied only to the selection. Selection tools are very useful for split-contrast printing, background control, discrete tonal or contrast adjustments, colorizing, and many more creative applications. You can also "feather" the selection to help make tonal borders blend; feathering options can be set on the tool's Options palette.

The Lasso tool allows you to make freehand selections around a portion of the image. You can draw using the mouse or using a stylus and tablet. If you want to add to your initial selection (either to enlarge the selection or to choose another portion of the image) you can hold down the Shift key before you begin and while making the next selection. If you do not press Shift, the original selection will become inactive as soon as you click on another area.

Selection, using any of the several tools available, is central to creating image effects. After making a selection, a series of moving dashes appears around the area.

The Magic Wand is another important selection tool. Choose the tool, then move the wand to an area within the scene. Click on the mouse and all areas that share the color (or tonal value for grayscale images) where the wand is will be selected. This is great for highlight control, colorizing, and other image manipulations. The Magic Wand tool's Options palette has a Tolerance setting that broadens or narrows the range of colors or tonal values the tool will select.

Quick Mask mode is useful for refining selections. Click on the rectangle with gray tone surrounding a white circle to activate Quick Mask mode. Reset to Standard mode (no color mask) by clicking on the icon to the left, an untoned rectangle surrounding a white circle.

Masking: The Quick Mask mode is invaluable for refining selections. Once you have made a selection, click on Quick Mask mode and a transparent red mask covers all but the selected area. (The color, opacity, and area covered by the mask can be set in the dialog box, which is accessed by double-clicking on the Quick Mask icon.) This allows you to check edges and modify them as required. Before refining your selection, make sure that you have black and white (not gray) set as the Foreground and Background colors respectively. Then add to the selection using the Airbrush, Paintbrush, or Pencil tool, or subtract from it using the Eraser tool. When finished, click on the Standard mode icon to remove the red mask; the selection marquee will remain on the screen.

The Select > Inverse command applies the mask to the previously unmasked area. You can, for example, mask off a portrait subject and apply effects, then invert the selection and work on the background. You can toggle back and forth between portions of the image as necessary.

Image 1

Image 2

Image 3

After selecting an area, the Quick Mask mode can be applied. The unselected area is covered by a mask (shown here in red). Paint tools, such as the Airbrush tool (Image 2), add to the mask, and the Eraser tool (Image 3) subtracts from the mask, provided the Foreground and Background colors are at the default settings of black and white, respectively.

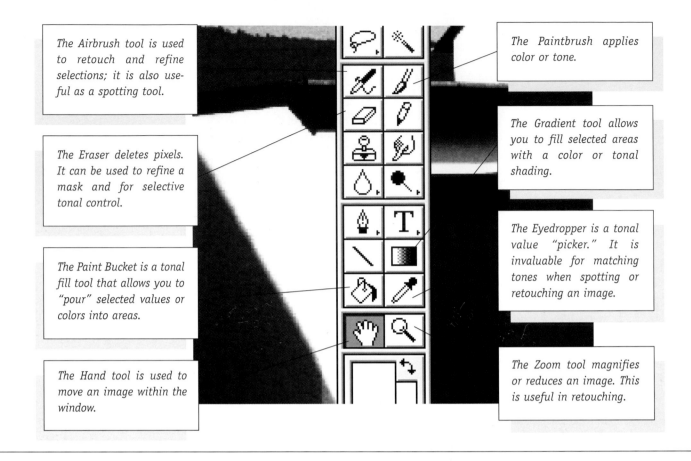

The Airbrush tool is used to retouch and refine selections; it is also useful as a spotting tool.

The Eraser deletes pixels. It can be used to refine a mask and for selective tonal control.

The Paint Bucket is a tonal fill tool that allows you to "pour" selected values or colors into areas.

The Hand tool is used to move an image within the window.

The Paintbrush applies color or tone.

The Gradient tool allows you to fill selected areas with a color or tonal shading.

The Eyedropper is a tonal value "picker." It is invaluable for matching tones when spotting or retouching an image.

The Zoom tool magnifies or reduces an image. This is useful in retouching.

Painting and Retouching: The painting tools can be altered and refined to deliver various opacities and amounts of coverage. Opening the Options palette (Window > Show Options) allows you to control their application. Opacity refers to the strength of coverage; lower numbers yield light coverage, while higher numbers increase the color's intensity. The Brush options (also available through Window > Show Brushes) determine the breadth of coverage and edge quality of the tool. Other options will be described later as we cover each tool.

The Eyedropper tool is invaluable for use with the retouching tools. Place the Eyedropper over the tonal value you wish to use, and click; the tonal value chosen will become the Foreground color that is used by the paint tools. This tool is a retoucher's dream, as it "mixes" precise retouching tonal values and colors for you.

The Airbrush tool simulates the functions of a traditional airbrush and is an excellent tool for spotting and retouching. The Paintbrush works as its name implies; options such as opacity and brush size are set on the Options and Brushes palettes. You can also set the brush for wet or dry application, the wet choice yielding a more diffuse stroke.

Fill: The Paint Bucket tool works along with selections. You can use this tool to control color, tonal value, and saturation. Select an area, choose a color or tone, then fill the area with whatever you have "placed" in the bucket. Similarly, the Gradient tool fills a selection with a blend of any two colors or tones. Both tools offer opacity adjustment on their Options palettes.

Another method for changing the color or tone of a selection is going to the main menu and choosing Edit > Fill. This will bring whatever color or tone you choose into the selected area. In the Fill dialog box you can choose a percentage of fill, thus defining the opacity of the effect.

Many tools allow you to vary the degree or intensity of their application. Double-click on a tool in the toolbox to open the Options palette.

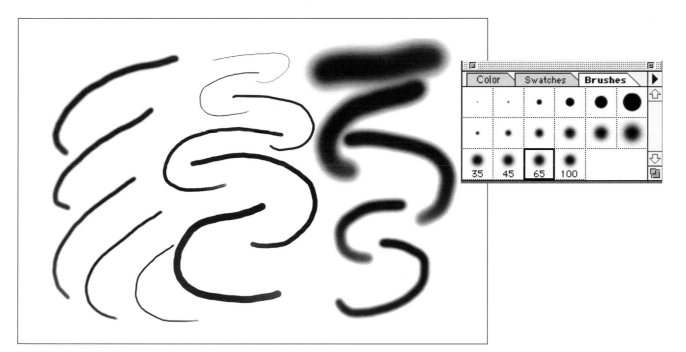

The Brushes palette allows you to vary the width, or "tip size," of the brush. Also, the "paint" can be applied as if from a wet or dry brush. The wet brush yields a more diffuse stroke.

For the paint tools, one option is to vary the opacity, or degree of application. The numbers here show the effect of different opacity settings with the Airbrush tool.

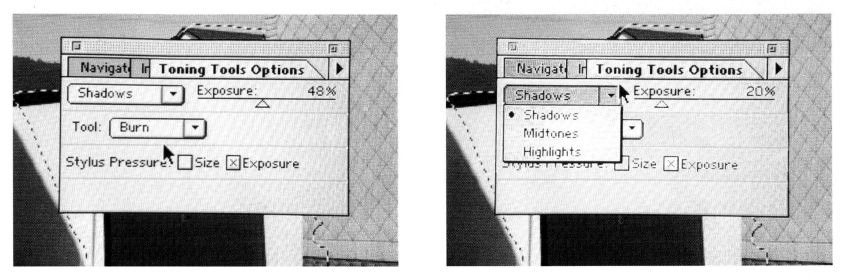

Open the Toning Tools Options palette by double-clicking on the tool, or choose Show Options under the Window menu. Experiment with the various settings using a range of values. When you burn and dodge, you can set the tools to the value range (shadows, midtones, or highlights) in which the action will take effect. All three Toning tools offer extra control through the use of the opacity settings on their palettes.

Burning and Dodging: The Burn, Dodge, and Sponge tools are grouped on the Toolbox. Just as in the darkroom—burning makes the area to which it is applied darker, while dodging lightens it. The Sponge tool decreases and increases saturation. This is more useful for color work, but can be used on tonal values.

The Burn/Dodge/Sponge tool's Options palette enables you to choose the opacity of the effect (with lower numbers being lighter) and the values in which you want the effect to take place. The options are Highlights, Midtones, and Shadows. If you have, for example, a highlight you want to clear that is next to a midtone area, select Highlights and dodge the area; only the highlights will be affected.

Color and Tone: The Foreground and Background color boxes are also important controls. When working in black and white they are usually kept at their default settings: black and white. Double-click on the Foreground color, and a color picker will be invoked. You can choose any color or shade of gray. The same goes for the Background color. You can toggle between the two colors or tones by hitting the "switch colors" arrows to the right of the two boxes.

The Foreground and Background color boxes can be assigned any tonal values you desire; the default settings are black and white respectively. This is where tonal values and colors for retouching, painting, and colorization appear when chosen with the Eyedropper tool or Color Picker. Foreground and Background values can be swapped by clicking the arrow toggle in the upper right-hand corner. You can return to the default settings by clicking on the small black and white squares to the lower left.

Image Workshop

The Image Workshop section of this book is intended to serve as a "recipe book" for creating effective black-and-white images through digital imaging. It covers basic image processing and corrective controls; general techniques; enhancements, refinements, and interpretations; special effects; and subject studies (effects for portraits, landscapes, still lifes, etc.). Each example is geared toward a specific technique.

The methodology is similar for each example shown. We cite the technique to be discussed, the image source (be it color or black and white, negative or slide), the source of the scan, and the working file size. Illustrations and text are used to explore the technique described. Each applied effect is listed sequentially by its command chain (e.g., Image > Adjust > Levels) and then followed by a more detailed step-by-step description, dialog box or palette settings, and results. Comments and tips are included with each example.

Imaging software programs have layer upon layer of controls; the ease with which you use them will become more refined and subtle as you gain practical experience with more and more images. The controls and tools cited here are just some that you may use on a consistent basis; others will emerge as your favorites as you work. Whenever possible, play with the software to get a feel for the many paths it offers and to discover new ways of creating exciting and effective images. The techniques described in this book are those that I have found to be effective; you will undoubtedly discover others or different ways of approaching an image. Indeed, every time I work on an image I discover new possibilities.

Alter aspect ratio for a more effective composition

Comments: Changing the aspect ratio (the height-to-width relationship) of an image can add emphasis to the subject matter via the altered point of view.

Image Source: 35mm black-and-white negative

Scan: Photo CD

File Size: 4.5 MB

■ Image 1

An initial print of the scanned image has low contrast and shows some dust marks. Composition can be improved by cropping to emphasize the vanishing point of the pier.

Steps: File > Open > 4.5 MB
 Cropping tool

The new aspect ratio of the print was outlined with the Cropping tool. The crop lines were not precisely positioned on the first "draw." The cropping mask was adjusted by dragging the corners of the superimposed frame. Clicking in the center of the mask applied the crop and deleted the unselected areas of the image.

■ Image 2

Steps: Filter > Unsharp Mask
 Image > Adjust > Levels
 Eyedropper tool
 Airbrush tool

The Unsharp Mask filter (set at 150%) was applied. The black and gray levels were adjusted using the Levels dialog box. This darkened the area surrounding the pier, giving it more emphasis. Spotting was done last to clean up the image.

TIP

Retouch the image after sharpening. Flaws that may not have been apparent are often revealed after this filter has been applied.

Image 1

Image 2

Comments: Images such as this one are excellent learning tools. The relative brightness and detail of the sky clearly illustrates adjustments in tonality and contrast. The aim is to familiarize yourself with the tools and to realize the potential of the controls. The ability to preview any changes prior to output is a real advantage, as you can customize images without going through an extensive proofing process.

Image Source: Medium-format black-and-white transparency

Scan: Photo CD

File Size: 6 MB; converted to grayscale, 2 MB

■ Image 1

The print was made directly from the scan.

■ Image 2

Steps: File > Open > 6 MB
Image > Mode > Grayscale
Image > Adjust > Levels

The image was first converted from RGB to Grayscale mode. All adjustments were made in the Levels dialog box by selecting the white point and black point in the image and working with the middle gray slider. A value in the mountain area was selected as the black point, and the white point was taken from the brightest portion of the sky. The gray slider was adjusted slightly to enhance subtle nuances of tone.

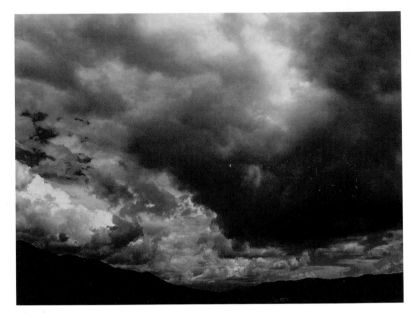

Image 1

TIP

Start with an image that has a wide variety of tones, from bright white to deep black and with a full scale of gray values. Then practice adjusting the controls to achieve images that range from "straight" reproduction to interpretive.

Image 2

Comments: While it is not suggested that you make a practice of working with poorly exposed negatives, there are times when you want to save an image. These techniques can salvage old images from family albums, or rescue a "blown" photo that could never be reshot.

Image Source: 35mm black-and-white negative

Scan: Photo CD

File Size: 6 MB; after grayscale conversion, 2 MB

■ Image 1

When the original negative is held up to the light, its details are barely visible. It is both extremely "thin" (lacks density) and "flat" (has virtually no contrast). In the darkroom, this negative would have to be printed on a #5 contrast grade paper, but even that degree of contrast might not be of much help. This print made directly from the scan was decidedly lackluster.

Steps: File > Open > 6 MB
Image > Mode > Grayscale

The image was first converted from RGB to Grayscale mode.

■ Image 2

Steps: Window > Show Layers > Copy (drag-and-drop)
> Copy > Flatten Layers

One way to build density in the computer environment is to make duplicates of the image in different layers, and then to merge those layers. Using the Layers dialog box, the "Multiply" option was chosen and three layers of the same image were created. The layers were then merged to create this denser version. Now that it has more density, the next stage is to create contrast.

Image 1

■ Image 3

Steps: Image > Adjust > Levels

Contrast is built through the Levels dialog box by contracting the tonal scale. Here, the controls were black: 12; white: 106; and gray: 1.10. This brought detail, albeit with high grain, to an otherwise unsalvageable image.

<div style="background:#ccc">

TIP

There are many ways to use Layers in image control and manipulation. Creating layers allows you to work a portion of the image without affecting the whole and then to merge the "worked" portion with the rest. Here, the layers were used to build onto an admittedly shaky foundation.

</div>

Image 2

Image 3

Comments: Internegatives or interpostives are needed for conventional silver printing or for alternative processes such as cyanotype, platinum, and palladium printing.

Image Source: 35mm black-and-white transparency

Scan: Photo CD

File Size: 4.5 MB

■ Image 1

Steps: File > Open > 4.5 MB

The scanned image had a good range of tones, but an internegative was needed for contact printing in the darkroom.

Image 1

■ Image 2

Steps: Image > Adjust > Levels
 Eyedropper tool
 Airbrush tool

After opening the Levels dialog box, the image contrast was raised slightly with the white and black point selections. Some minor retouching was done using the Airbrush tool. The Eyedropper tool was used to match tones in the areas that needed retouching.

■ Image 3

Steps: Image > Adjust > Inverse

A negative image was created using the Image > Adjust > Inverse selection.

At this point the image can be saved and output to film. This requires a film recorder, a device that "writes" the digital file onto silver-halide film. Generally, any lab or service bureau that handles scans also has film recorder services.

TIP

To determine file setup for a specific process, consult with the lab doing the printing or the service bureau producing the internegative or interpositive, or match the file specifications to film outputs you have had success with in the past. Different processes, film types, and formats have specific density and contrast requirements that are necessary to optimize results.

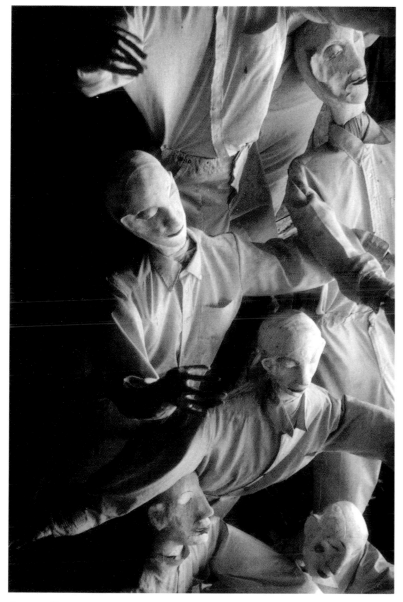

Image 2

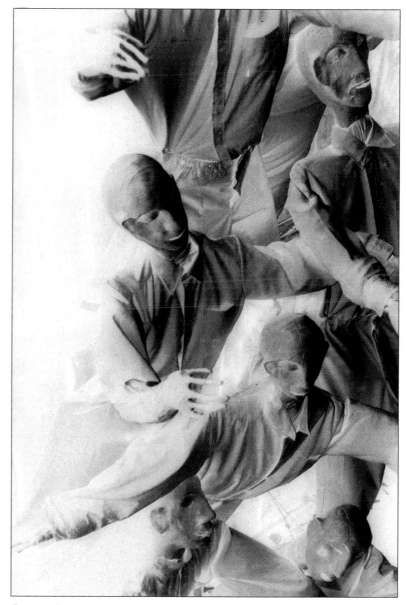

Image 3

Comments: When photographing landscapes that include sky, certain filters reduce blue exposure and heighten the contrast between the clouds and the background. To make the sky progressively darker you would use a yellow, orange, or red filter, respectively. Simulating this effect in the computer imaging environment is a simple matter, as the sky, regardless of how complex the horizon line, can be selected and treated to various degrees of contrast.

Image Source: 35mm black-and-white negative

Scan: Photo CD

File Size: 4.5 MB

■ Image 1

This photograph of the Vietnam Memorial in Angel Fire, New Mexico, was made without a filter on the lens. The blue sky filled with billowing clouds is a perfect candidate for enhancement.

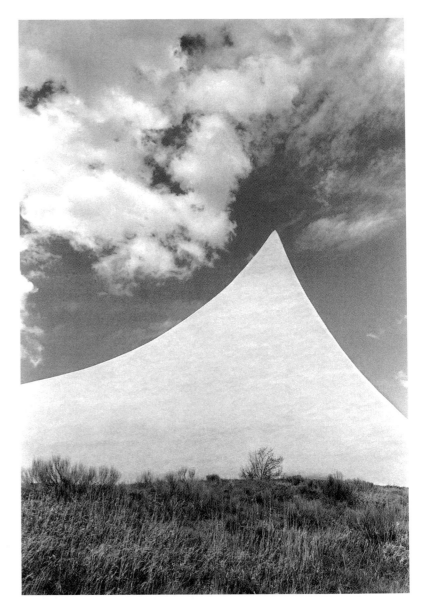

Image 1

■ Image 2

Steps: File > Open > 4.5 MB
Lasso tool
Quick Mask mode
Airbrush tool
Image > Adjust > Levels

The sky area was selected, Quick Mask mode was employed, and the selection was refined with the Airbrush tool. The contrast between the clouds and the blue background was increased using Levels. Both the highlights and shadows Input sliders were moved closer towards the center to increase contrast until the image emulated the scene as photographed through a red filter.

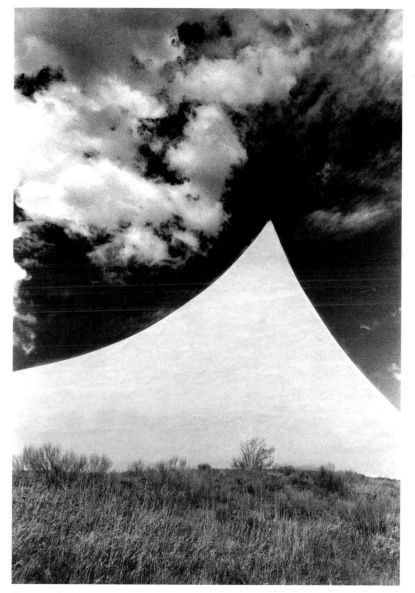

Image 2

Comments: This technique is certainly familiar to darkroom printers. The advantage in the digital realm is that the tools can be set for exposure or degrees of effect. This yields a tremendous amount of control and allows for very discrete adjustments.

Image Source: 35mm black-and-white negative

Scan: Photo CD

File Size: 4.5 MB; after grayscale conversion, 1.5 MB

■ Image 1

Steps: File > Open > 4.5 MB
 Image > Mode > Grayscale

The scan revealed all the detail in the image, but the print was hardly satisfactory. The aim was to completely alter the mood and create a center of light in the image.

■ Image 2

Steps: Burn tool
 Dodge tool

The entire image was altered with the Burn and Dodge tools. Broad strokes of the Burn tool, set at Midtones, Exposure: 30%, handled the foliage and ground. Some areas were left open or burned at 10% to create a sense of movement in the light and to avoid an overall tonal "wash." The Dodge tool was set on Highlights, Exposure: 20% to enliven the reflective quality of light on the tree bark.

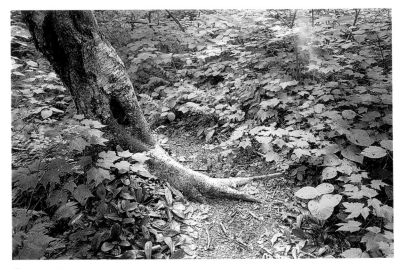

Image 1

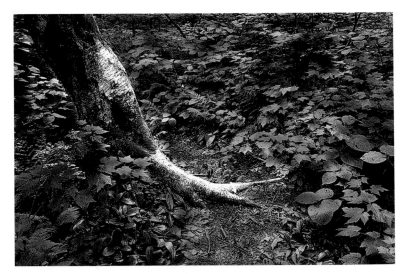

Image 2

TIP

Change opacities as you work to create variations in the effect. Always working with the same opacity will give a flat look, similar to going into Levels and applying controls to the entire image.

Comments: Edge burning is a time-honored technique among printers used to emphasize the subject by forming a "center of light." The idea is that the eye is drawn to the lightest portion of the print first, and then works its way outward. Here, the edge burn creates a more dramatic mood in the scene as well.

Image Source: 35mm black-and-white negative

Scan: Photo CD

File Size: 4.5 MB

■ Image 1

Steps: File > Open > 4.5 MB

Although this photograph has been mistaken for an image of a fog-shrouded valley, it is actually of a twig in a frozen stream. The moss and other textures around the edge of the ice add an interesting context.

■ Image 2

Steps: Burn tool

To enhance the image, the edges were darkened with the Burn tool at Midtones, Exposure: 50%. Some of the highlights in the ice were burned in using the Burn tool set at Highlights, Exposure: 20%. This added more shape to the "clouds" surrounding the twig.

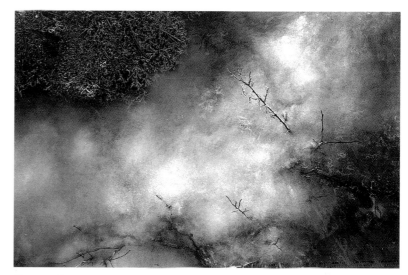

Image 1

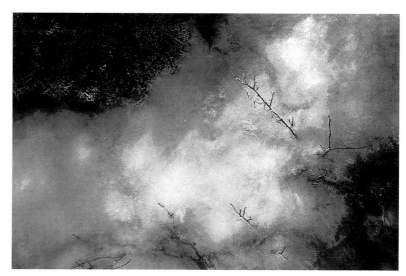

Image 2

TIP

Each stroke of the Burn tool over an area will add "density," i.e., darken the pixel values. Burn with an exposure setting that is less than you desire and build up areas as you work. The tonal values of the burn are further controlled by using the Burn tool to affect the shadow, midtone, or highlight values. Use both the tonal range and exposure settings to control the continuity of tone while using the Burn tool.

■ Contrast Control:
Change contrast grades

Comments: This effect is the same as changing the contrast grade of the printing paper from grade #1 to grade #3 in conventional darkroom printing. The beauty is that you don't have to make test strips, change filters, or calculate exposure times for the filtration adjustment, as results are previewed on the screen as you work.

Image Source: 35mm black-and-white negative

Scan: Photo CD

File Size: 4.5 MB

■ Image 1

Steps: File > Open > 4.5 MB

The print from the scan shows a good range of tones, but contrast needed to be increased to emphasize the shadow and bring more "pop" to the image.

■ Image 2

Steps: Image > Adjust > Levels

Raising contrast is easy by working in the Levels dialog box; here the black and gray sliders were moved without touching the white (255) setting. The changes were previewed on the screen prior to clicking on OK.

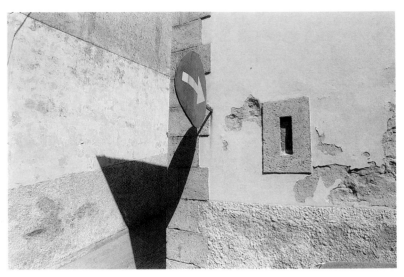

Image 1

Image 2

TIP

To deepen shadows while retaining the overall tonal relationship, use the Input Levels and work with the black slider and fine tune with the middle gray slider. Leave the white slider in place as this will maintain the highlights without "flattening" the image.

■ Contrast Control:
Selective tonal control

Comments: When you are altering contrast or brightness values of an area, choose your tools according to the size of that area and the uniformity or diversity of its tonal value. Here, the tone is adjusted in a fairly large and uniform portion of the scene. In this and similar cases, working with overall selection is best; if the area was smaller and more tonally diverse, a combination of burn and dodge controls would make more sense.

Image Source: 35mm color transparency

Scan: Photo CD

File Size: 18 MB

■ Image 1

Steps: File > Open > 18 MB
 Image > Adjust > Desaturate
 Filter > Sharpen > Unsharp Mask

The first stage is to remove color, which is accomplished with the Desaturate command. To create a brisk feel in the plant and dunes, the image is sharpened by applying the Unsharp Mask filter, Amount: 150%.

Image 1

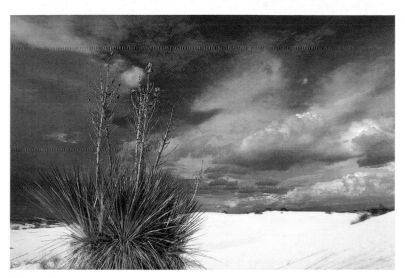

Image 2

■ Image 2

Steps: Lasso tool
 Quick Mask mode
 Airbrush tool
 Eraser tool

The original photograph had excellent tonal values in the sky, but the light on the sand dunes was a bit dull. To retain the values in the sky, the ground was selected with the Lasso tool. The Quick Mask mode was applied and the masked area was refined with the Airbrush tool and the Eraser tool. Portions of the mask were deleted to uncover some of the plant stalks and include them in the tonal adjustments.

Steps: Image > Adjust > Levels
 Burn tool

The areas not covered by the mask were lightened using the Levels controls. To blend tones, the Burn tool was applied to the border between the sky and the ground; it was also used on some of the clumps of grass within the dunes.

TIP

After lightening, darkening, or changing the contrast in a selected area, refine the work with Burn and Dodge controls. This will blend tonal borders, plus create visual play within what would otherwise be a blanket tonal change.

■ Contrast Control:
Selective highlight control

Comments: Fine control of highlights in the darkroom is commonly done with a process of selective reduction called "bleaching." After a print is processed, a solution of potassium ferricyanide is mixed and applied with a brush or cotton swab; when reduction is satisfactory the action is halted with fixer.

Tools, such as the Dodge tool, Sponge tool, and Eraser tool, can be used to selectively reduce highlights in a digital image. Work should be done in stages, with each stage being saved as you go.

Image Source: Medium-format color transparency

Scan: Photo CD

File Size: 72 MB; after grayscale conversion, 18 MB

■ Image 1

Steps: File > Open > 72 MB
Image > Mode > Grayscale

A print from the original scan has very good detail, but overall the image was flat and the chrome receded into the middle values. The image needed contrast and the chrome needed to be brought into relief through selective reduction of density.

■ Image 2

Steps: Image > Adjust > Levels

The first step was to increase contrast. This was done using the Levels controls; the white point was placed on the chrome strip on the grill and the black point on the shadow area of the bumper. (Contrast could also be increased using the sliders in the Levels dialog box or changing the Curve shape of the image.)

■ Image 3

Steps: View > Zoom In
Dodge tool

The next challenge was to open up the center strip of chrome to match the brightness of the grill. In a darkroom this could be done by "bleaching" the print. Here, the chrome strip was zoomed in on to allow for finer control, and the Dodge tool was used at 70% with highlights selected as the area to be affected. The areas were worked in stages and carefully examined after each area was dodged. The words "Buick Eight" were enlarged before dodging to avoid affecting adjacent tonal areas.

■ Image 4

Steps: Magic Wand tool
Foreground color
Color picker
Edit > Fill

To bring tonal variety to the scene and not have the highlights compete visually with the reflections on the car, the tonal areas on the car body were selected with the Magic Wand tool at a very broad tolerance of 75. The Color picker was opened by double-clicking on the Foreground color in the toolbox and a fill color was chosen. Then, using the Edit > Fill command, the chosen tonal value was added to the selected area. A slight posterization effect resulted from the large areas selected due to the wide tolerance setting.

TIP

When doing selective reduction, zoom in on the area in which you're working, and move around the image using either the Hand tool or the slider control in the surrounding frame.

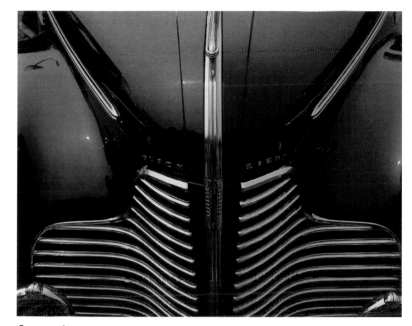

Image 1

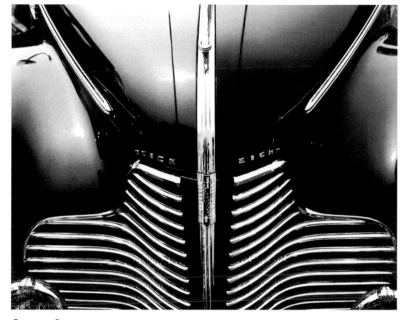

Image 3

Image 2

Image 4

■ Contrast Control:
Selective tonal control with the Burn tool

Comments: While the original tonality in the image is pleasing enough, offsetting the flowers against the background added depth and lent the flowers a glowing, almost surreal feel. These types of interpretive decisions make for exciting prints and give the printer a true sense of involvement in the image-creation process. Adjustments in tonality can be used to define the primary subject in the scene.

Image Source: 35mm black-and-white negative

Scan: Photo CD

File Size: 4.5 MB

Image 1

■ Image 1

Steps: File > Open > 4.5 MB

The scanned negative yielded a fairly high-key print, with even tonality throughout. The decision was made to first add contrast to emphasize the form and shape of the flowers.

■ Image 2

Steps: Lasso tool
Select > Inverse
Quick Mask mode
Airbrush tool
Image > Adjust > Levels

The Lasso tool was used to select the flowers. The selection was then inverted so that the remainder of the scene would be affected by the tonal changes and the flowers would retain their original tonality. Quick Mask mode was applied and the Airbrush tool was used to refine the selection. The Levels dialog box was called up, and the background area was darkened.

■ Image 3

Steps: Burn tool

The Burn tool, set for Midtones, Exposure: 30%, was then used to selectively darken areas. Close attention was paid to the edge of the image, particularly the upper and lower left-hand corners. This defined the image borders and centered attention on the selected flowers.

TIP

When changing tonality to create dimensionality, pay close attention to the details in the corners and edges of your prints. Edge burning, making edges slightly darker than the center, can be a subtle way to direct the viewer's eye and create a sense of enclosure in the image.

Image 2

Image 3

■ Contrast Control:

Printing from a dense, high-contrast negative

Comments: It is always better to work from a good negative for scans as the dictum: "Garbage in, garbage out" implies. When working with harsh, overexposed negatives, do not sacrifice overall tonality by compressing the tonal scale; rather, control the levels of tonality selectively. Use the Preview option before saving to eliminate the need for endless trial and error.

Image Source: A very overexposed 35mm chromogenic negative with excessive density overall, particularly in the highlights.

Scan: Photo CD

File Size: 18 MB; after grayscale conversion and cropping, 6 MB

■ Image 1

Steps: File > Open > 18 MB

　　　　　Image > Mode > Grayscale

This is the image as it appeared from the original scan. Scanning improved the very harsh negative slightly by compressing the tonal values. The image is still flat and somewhat lifeless.

Image 1

■ Image 2

Steps: Image > Adjust > Levels

In the Levels dialog box, the Input Levels for black and white were left at the 1 and 255 settings, but the middle gray level was adjusted to 0.52, which enriched the middle values without sacrificing deep blacks or highlights.

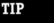

TIP

Images such as this have to be worked in stages. The first step is to create a foundation from which you can later make selective area adjustments. Once the overall tonality is established, as seen here, the next stage would be to dodge the dark areas to reveal image detail and information.

Image 2

■ Contrast Control:
Create a high-key rendition

Comments: High-key images rely on white and light shades of gray to communicate mood. Image areas that might detract from this feeling were cropped out, and the image was opened up by lightening the tones overall.

Image Source: 35mm black-and-white negative

Scan: Photo CD

File Size: 4.5 MB

■ Image 1

Steps: File > Open > 4.5 MB

This image is about quality of light, and the way that it falls through the curtain and blind. The print from the scanned image came out a bit dark. The treatment should be lighter overall.

■ Image 2

Steps: Cropping tool
 Image > Adjust > Levels
 Filter > Sharpen > Unsharp Mask

First, the image was cropped to delete the upper portion, thus eliminating a dark area of the scene. In the Levels dialog box the image was lightened by placing the gray point on the blind and the black point on the right side of the wash bowl; this kicked up (lightened) the rest of the image without sacrificing the highlights. To help enhance the diffuse effect, Unsharp Mask was chosen. The image was not sharpened; the Amount setting was 1 and the Radius setting was 1. The Threshold setting, however, was set to 20, which softened the edges and added a degree of diffusion.

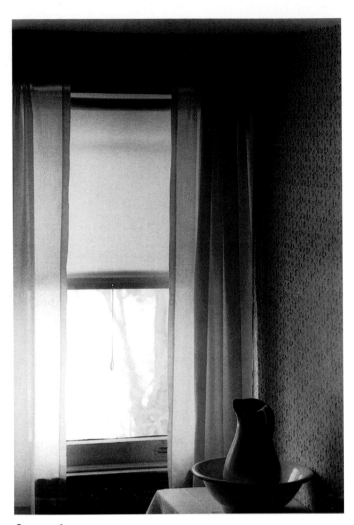

Image 1

TIP

While the Unsharp Mask filter is usually used to add definition to an image and delineate lines and forms, it is used here to soften the lighting effect. The Threshold setting of the Unsharp Mask filter is worth exploring for scenes such as this, as well as for portraits and moody landscapes.

Image 2

■ Contrast Control:
Contrast manipulation with white and black point selection

Image 2

Comment: Photographic papers offer a contrast range of 0–5 in half steps, with some further contrast manipulation available through developer type, dilution, and temperature. With digital imaging there's no need for trial and error, and the contrast control is greater. Once a certain contrast has been selected, small areas can be easily burned or dodged with no adverse effect on the overall image. Thus, images can be perfectly matched with any desired contrast rendition.

Image Source: Medium-format black-and-white negative

Scan: Photo CD

File Size: 18 MB; after grayscale conversion, 6 MB

■ Image 1

Steps:　File > Open > 18 MB
　　　　　Image > Mode > Grayscale
　　　　　Filter > Sharpen > Unsharp Mask

An excellent negative can make "straight" printing from digital scans a breeze. This negative has a full range of tones, which yields detail in shadows and highlights and a smooth tonal transition. The only adjustment to this image was sharpening at 100%.

Image 1

■ Image 2

Steps:　Image > Adjust > Levels

To experiment with contrast rendition, the Levels dialog box was opened. Black and white point placement were the only controls used, and the Preview option was set to see adjustments as they were made. Here, the white point was selected in a light gray area of the image, which brought up all the other values as well. This resulted in more open shadows and very little detail in the highlights; blacks are good but not rich.

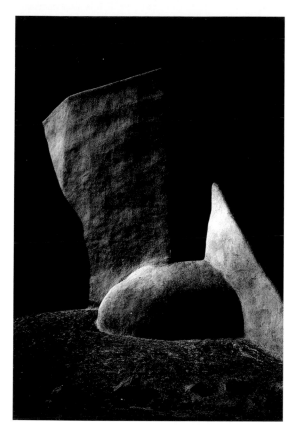

Image 3

■ Image 3

The black point was placed in a very light gray area to create this image. This drove values down and darkened the image substantially; the few highlights are harsh. This rendition created an abstraction of the forms, but sacrificed image information.

TIP

This technique emphasizes the need for monitor calibration, as contrast is one of the key definers of black-and-white image rendition. Viewing the effects of black and white point selection is integral to understanding image control.

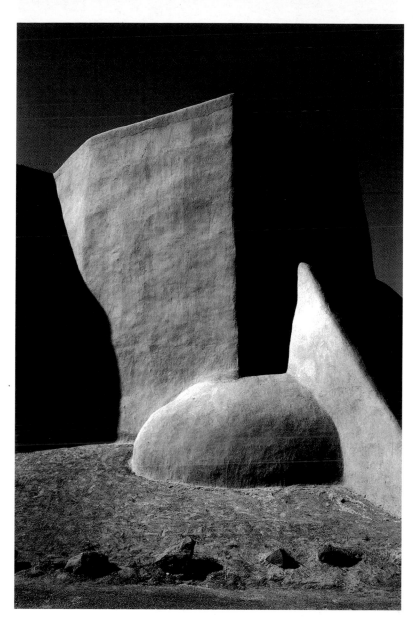

Image 4

■ Image 4

Here, the black point selection was made in the open shadows, which dropped the values down but still retained the integrity of the forms. This rendition was chosen as the final because it accentuated the strength of the forms and created depth in the sky.

■ Contrast Control:

Brightness and contrast controls

Comments: The Brightness/Contrast controls can be used for a quick fix on an image, but they do not offer the degree of control available in the Levels and Curves controls. Generally, Brightness/Contrast is better used for minor corrections after Levels and/or Curves adjustments are applied.

Image Source: 35mm black-and-white negative

Scan: Photo CD

File Size: 18 MB

■ Image 1

Steps: File > Open > 18 MB

The original from the scan came through somewhat "flat." This is actually an advantage as image details in highlights and shadows are available and can be easily adjusted.

■ Image 2

Steps: Image > Adjust > Brightness/Contrast

Brightness/Contrast adjustments are applied "across the board." They affect the entire tonal range of the image, unlike the Levels and the Curves controls, which work selectively on the black, gray, and white values. Here, the Contrast setting was raised to +25%, which resulted in deep shadows and harsh highlights.

■ Image 3

In an attempt to tone down the highlights the Brightness control was used to darken the image by -30%. This muted the highlights, but created a "veil" over the image.

■ Image 4

Steps: Image > Adjust > Levels

Here, the Levels dialog box was used to optimize the image. The white and black points were chosen, and the gray level slider was properly adjusted for the middle tones.

TIP

Image processing software that lacks the capabilities offered by the Levels or Curve controls may limit your ability to get the most out of images. Simply making a "blanket" adjustment, rather than having the option to work the gray levels, will limit your ability to create the best possible results.

Image 1

Image 2

Image 3

Image 4

■ Contrast Control:
Explore tonal adjustments and variations

Comments: Selective contrast control in small, individual areas of an image is one of the most powerful tools offered by digital imaging. In this example the effects are exaggerated, done so to display the capabilities of the system. This precise, localized control is difficult at best in conventional darkroom work. In the digital darkroom, seeing results in real time as controls are applied fosters new-found powers in creative imaging.

Image Source: 35mm black-and-white negative

Scan: Photo CD

File Size: 6 MB; after grayscale conversion, 2 MB

■ Image 1

Steps: File > Open > 6 MB
 Image > Mode > Grayscale

The full range of tones in this image made it an excellent candidate for contrast and tonal exercises.

Image 1

■ Image 2

Steps: Lasso tool
 Foreground color
 Color picker
 Paint Bucket tool

To manipulate values, different parts of the image were first selected with the Lasso tool. After an area was selected, the Foreground Color box in the toolbar was double-clicked on and a tone was chosen from the Color picker. Then the Paint Bucket tool was activated, moved over the selected area, and applied.

■ Image 3

Steps: Lasso tool
 Eraser tool
 Image > Adjust > Levels

To intensify the eyes, they were selected with the Lasso tool and lightened with the Eraser tool. (The Background Color must be set as white.) This is one way to apply selective reduction to parts of an image. Finally, the Levels dialog box was used to darken the image and increase contrast.

TIP

There are many ways to control density and tones; work with each one to attain a comfort level, and then move on to the next. Work with assigning Foreground and Background tones in the toolbox, and applying them with paint and fill tools. Use the Eyedropper tool to select specific tones from within the image itself.

Image 2

Image 3

■ Contrast Control:
Black and white point placement

Comments: For those who have worked in the darkroom, the ease with which computer imaging allows for contrast variations of an image is startling. While some images call for a specific interpretation or require corrective procedures that force a contrast choice, scenes such as the one in this example encourage experimentation and variety.

Image Source: Medium-format color transparency

Scan: Photo CD

File Size: 18 MB; after cropping and grayscale conversion, 4.5 MB

■ Image 1

Steps: File > Open > 18 MB
Cropping tool
Image > Mode > Grayscale

The image was cropped from square format and converted from RGB to grayscale. The print yields a very satisfactory rendition with a smooth, low-contrast tonal spread, very much like a print made on a #2 contrast grade paper using an enlarger with a cold-light head.

■ Image 2

Steps: Image > Adjust > Levels

In this image, contrast was raised in order to sharply define the subject's tonal and textural aspects. Here, the range of tones is compressed by placing the white point on the white sand dune and the black point on the deepest shadow under the curl of the dune in the foreground. This change in contrast made every grain of sand in the image seem to "pop out."

■ Image 3

Another option is to go "high key," which emphasizes a lighter tonal rendition of the scene. Here, the white point was again set on the white dune, and then the Output Levels black point slider was moved toward the white point. This suppressed the blacks, lightened the image overall, and made the sky and the foreground sand very similar in tone.

> ### TIP
>
> *When you want to raise contrast in a scene, compress the tonal scale and adjust the middle grays to modify the effect. To create a high-key image, suppress the black by using a higher number for the Output Levels black point setting while keeping the white point at the maximum (255) setting.*

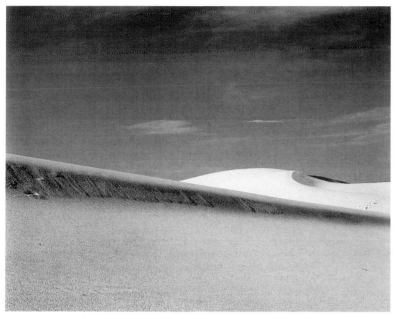

Image 1

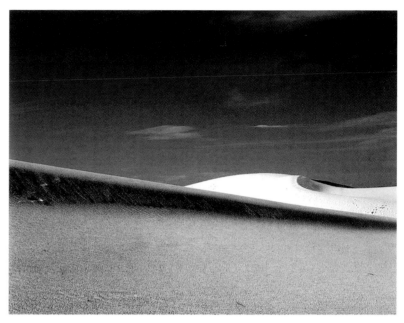

Image 2

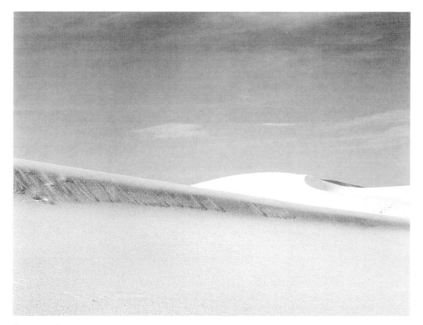

Image 3

■ Contrast Control:
Enhance the quality of light

Comments: The charm of working in the digital realm is that you can make very selective lighting decisions to enhance the mood and feeling of the final image. Here, splitting the scene through masking allowed for the play and the placement of specific brightness values in select portions of the image.

Image: 35mm color transparency

Scan: Photo CD

File Size: 6 MB; after grayscale conversion, 2 MB

■ Image 1

Steps: File > Open > 6 MB
 Image > Mode > Grayscale

The original scanned somewhat flat. The image was taken on an overcast day with soft, directional light coming from the upper-left portion of the frame; shadows cast by the fence indicate the direction of the light.

■ Image 2

Steps: Lasso tool
 Quick Mask mode
 Airbrush tool

A decision was made to brighten up portions of the sand while maintaining the middle values in the background, thus creating a mottled lighting effect. The first step was to select and mask off the background so it could be treated separately from the foreground. The foreground area was selected with the Lasso tool, Quick Mask mode was applied, and the mask was refined with the Airbrush tool.

Steps: Image > Adjust > Levels
 Select > Inverse
 Image > Adjust > Levels
 Image > Adjust > Brightness/Contrast

With the foreground area active, the Levels dialog box was opened and the white point was placed on the brightest part of the sand. This immediately raised the contrast in the foreground. Neither the black point nor the gray levels were changed. The selection was then inverted so that work could be done on the background. Here, the black point in Levels was placed on the vegetation at the water's edge. To enhance the mood further, the Brightness/Contrast dialog box was opened and the area was darkened by 25%.

TIP

Divide an image into distinct areas—foreground and background, subject and surroundings, sky and land—using one of the selection tools. You can then toggle between the two sections with the Inverse command. Thus, you can find the proper tonal balance between areas by applying effects first to one, then the other area, as you work through the creative process.

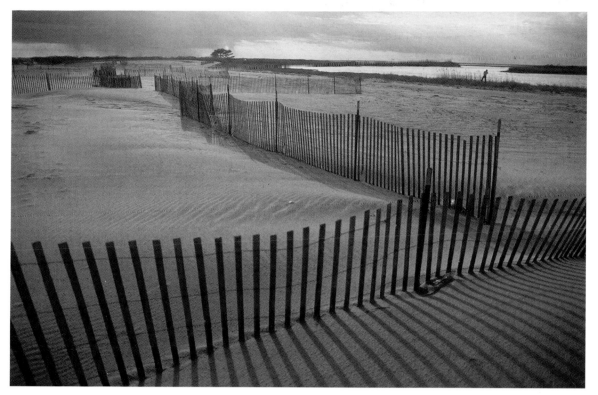

Image 1

Image 2

■ Contrast Control:
Split-contrast printing

Image 1

Comments: In conventional darkroom printing, split-contrast printing, also called split-filtration printing, is a trying technique. If there is no other technique that illustrates the ease of working in the digital realm, split-contrast printing should close the deal. Those who have labored in the darkroom with such images will recognize this immediately, especially when borders are as uneven as they are here.

Image Source: Medium-format black-and-white negative

Scan: Photo CD

File Size: 4.5 MB

■ Image 1

Steps: File > Open > 4.5 MB

The ground is well exposed, but the sky is washed out. This is a classic example of an image that would benefit from split-contrast printing. To print this conventionally, the sky and the ground would be exposed separately through different contrast grade filters onto variable-contrast paper. The sky portion would be blocked as you exposed the ground, and the ground portion would be held back as you printed the sky. In short, this is a fairly complex procedure, especially with such a difficult tonal break between the two areas.

> ### TIP
>
> *When working with split-contrast printing, do not hesitate to touch up certain areas and make spot improvements to contrast. Here, the lighter tones of some of the trees and shrubs were deepened with selective burn controls.*

■ Image 2

Steps: Lasso tool
Quick Mask mode
Airbrush tool
Eraser tool
Image > Adjust > Levels
Select > Inverse
Image > Adjust > Levels

To work on each area separately, first the sky portion was selected with the Lasso tool. The selection was refined in Quick Mask mode using the Airbrush and Eraser tools. (With the Foreground and Background default colors set, the Airbrush adds to the selection and the Eraser removes from the selection. Zoom in on the image for better selection control as you work.) Image > Adjust > Levels was employed to adjust contrast and tonality, and changes were previewed as work was done. Then the selection was inverted with Select > Inverse, and the same procedures were followed for the ground.

Steps: Burn tool

After studying the print to see how tonal areas blend, the edges were burned in with the Burn tool set at Exposure: 20%—a very light touch. Burning was also applied to select areas of the trees and shrubs to add "snap" to the overall image.

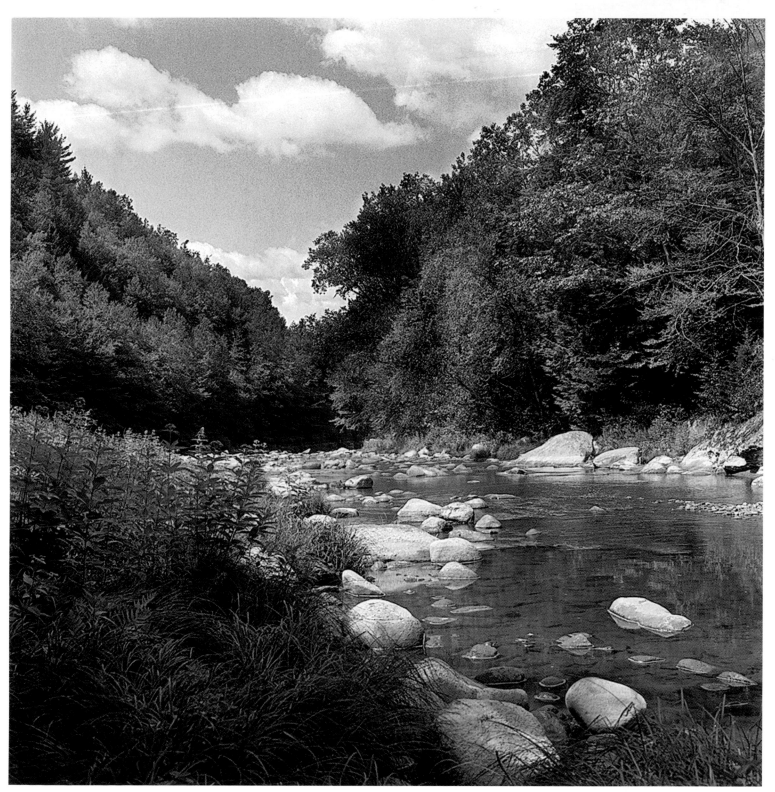

Image 2

■ Contrast Control:
Manipulate gray values

Comment: This exercise serves as a revelation for all who have toiled in the darkroom attempting to attain fine tonal control. With computer imaging you can lock in various tonal values and then shift other values, all without endless trial and error and experimentation with contrast grades. With Levels control you can fix black, white, and middle gray points using histograms and sliders, and even control light and dark values with the output controls.

Image Source: 35mm black-and-white negative

Scan: Photo CD

File Size: 18 MB; after grayscale conversion, 6 MB

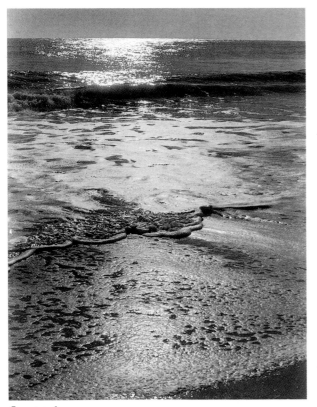

Image 1

■ Image 1

Steps: File > Open > 18 MB
Image > Mode > Grayscale

The print directly from the scan appeared flat, especially when compared to the original negative.

■ Image 2

Steps: Image > Adjust > Levels

The first step was to set the white and black points to enhance the tonal richness. The white point was set on the spectral highlight near the horizon; the black point was placed under the curl in the wave. The middle gray was left untouched. The image improved, but the potential was still not met.

■ Image 3

To brighten up the print without affecting the richness of the spectral highlight and the deep black, the middle gray slider was moved. This opened up the middle grays slightly and brought a greater range of tones to the image.

■ Image 4

Again, with white and black points fixed, the middle gray slider was moved to further open up the middle tones. The final print rendered the full rich potential of the image.

TIP

For most images, finding the optimum highlight and shadow is the first step, as this sets up the parameters of the tonal range. Adjusting the middle gray levels follows, and it is key to opening up the overall image.

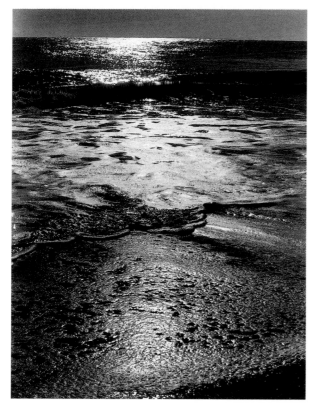
Image 2

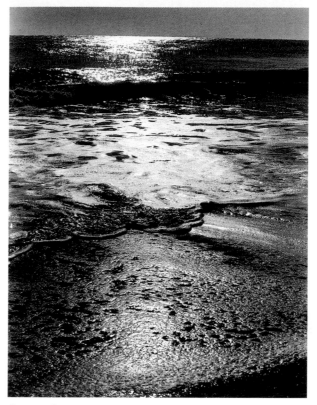
Image 3

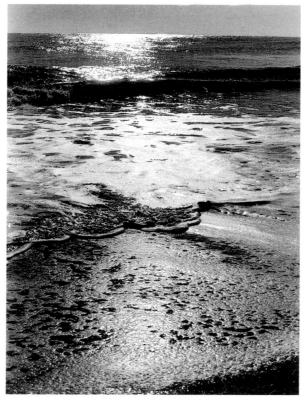
Image 4

■ Contrast Control:
Selective tonal control with the Burn tool

Comments: An abstract image is open to many interpretations. In black and white, most interpretive printing is done by adjusting contrast and exposure controls. Selective burning can be used for dramatic emphasis. Here, the tonal values of the rock face were near perfect; it was just a matter of bringing the rest of the image into sync.

Image Source: Medium-format black-and-white negative

Scan: Photo CD

File Size: 4.5 MB

■ Image 1

Steps: File > Open > 4.5 MB

The dramatic rock formation serves as a strong counterpoint to the sandstone wall and tumbleweed. The rock face is just the right tone, but the remainder of the image is a bit flat.

■ Image 2

Steps: Lasso tool
Quick Mask mode
Airbrush tool
Select > Inverse
Image > Adjust > Levels

To preserve the tonal value and contrast on the rock face, the area was selected using the Lasso tool, Quick Mask mode was set, and the selection was refined with the Airbrush tool. The selection was then inverted so that the remainder of the image could be worked; this work was done in the Levels dialog box. The contrast was raised by compressing the tonal scale.

■ Image 3

Steps: Burn tool

To make the tumbleweed stand out even more, the rock wall and ground were darkened using the Burn tool set at 40% exposure. Strokes were made to coincide with the pattern of the wall, with finer controls applied in and around the tangle of branches.

TIP

When selectively burning in an area, work patiently, check the effect before you move to the next stroke, and save as you go. If a mis-stroke is applied, you can use Edit > Undo or File > Revert to restore the image. If you do not continuously assess the effect as it is applied, you may have to resort to corrective techniques or dump the image and start over.

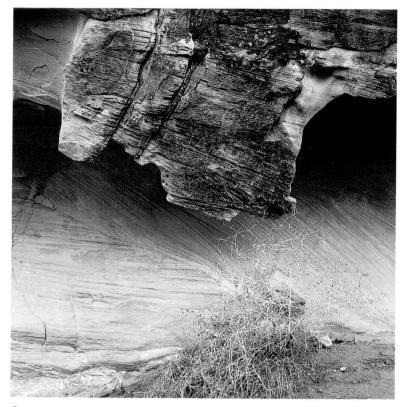

Image 1

Image 2

Image 3

■ Contrast Control:
Explore form through variations in tone and contrast

Comments: Try various interpretations to explore the image's full potential. Adjustments to contrast and tonality can bring various elements forward or cause them to recede.

Image Source: 35mm black-and-white negative

Scan: Photo CD

File Size: 1.5 MB

■ Image 1

Steps: File > Open > 1.5 MB

This scene of leaves frozen in a pond holds many subtle forms and shapes. The aim is to explore those forms by having them emerge from their surroundings.

■ Image 2

Steps: Lasso tool
 Quick Mask mode
 Airbrush tool
 Image > Adjust > Levels

To accentuate the form on the right, it was selected using the Lasso tool and refined in the Quick Mask mode using the Airbrush tool. The shape was then separated from the background by increasing its contrast in the Levels dialog box.

■ Image 3

Steps: Burn tool
 Dodge tool
 Select > Inverse
 Image > Adjust > Levels

While this successfully separated the form, some darker tones needed to be opened up to show detail. The top right side of the form was burned in (Highlights, Exposure: 20%) to give it more texture and alleviate some of the excessive contrast. The Dodge tool (Midtones, Exposure: 30%) was used to open up some of the areas and bring detail out. The selection was then inverted, and the background was lightened using Levels.

■ Image 4

Steps: Cropping tool
 Image > Adjust > Levels

Using the Cropping tool, a portion of the image was selected. The selection was refined by dragging the corners into position and then the image was cropped by clicking inside the selection. The Levels dialog box was opened and the image was lightened.

TIP

When you apply overall tonal adjustments to an area there may be a need to selectively modify areas with the Burn and Dodge tools to create tonal play. Use the proof print or the original image as a guide when determining where modifications should be made.

Image 1

Image 3

Image 2

Image 4

■ Contrast Control:
Tonal variations with the Magic Wand tool

Comments: While there are various ways to adjust tonal values in a scene, the Magic Wand tool makes selections of specific tonal values within discrete areas of an image. The Tolerance setting determines the range of values recognized by the Magic Wand tool. Practice with different Tolerance settings to get a feel for how broad or narrow an area will be selected.

Image Source: 35mm black-and-white negative

Scan: Photo CD

File Size: 1.5 MB

Image 1

■ Image 1

Steps: File > Open > 1.5 MB

There is a wide variety of tones in this image, all played out in concentric circles around the rock. The tonal range is somewhat compressed, however, and this print from the scan appears flat.

■ Image 2

Steps: Magic Wand tool
Color picker
Edit > Fill

Double-clicking on the Magic Wand in the toolbox evoked the tool's Options palette. The Tolerance was set at 5, which meant there was little room for variation in the selection of tonal areas. Areas of the image were selected using the Magic Wand. After selection, the Foreground color in the toolbox was clicked on, which evoked the Color picker. A tone was chosen and applied to the selected areas with the Edit > Fill command. Various portions of the image were selected and differing degrees of opacity were set in the Fill dialog box.

TIP

The Eyedropper tool is another option for "picking" tonal values. Any color or tonal value that is clicked on with the Eyedropper tool becomes the Foreground color.

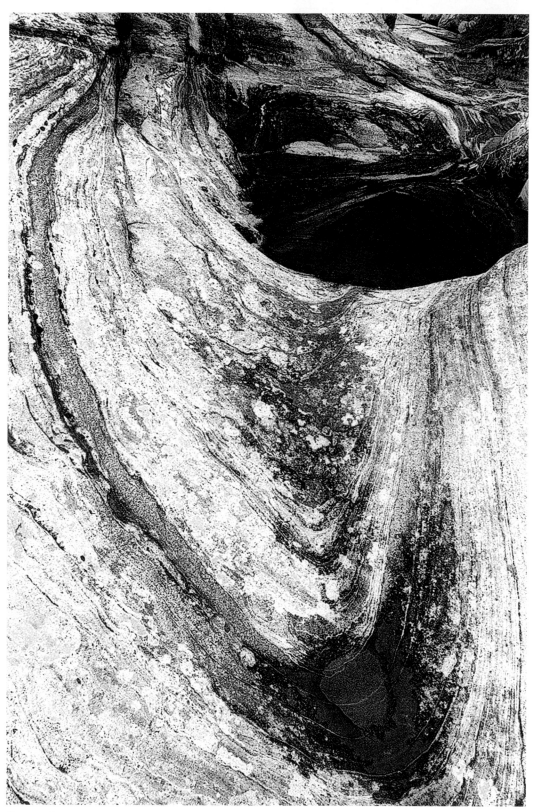

Image 2

■ Contrast Control:
Image interpretation through tonal control

Comments: By changing the contrast and tonal relationship the entire feeling of light in the image is altered. While not quite "day for night," the mood and even the "temperature" of the scene was changed. Often, images shot in fairly "flat" light leave room for the widest range of interpretations.

Image Source: 35mm color transparency

Scan: Photo CD

File Size: 4.5 MB

■ Image 1

Steps: File > Open > 4.5 MB

Image > Adjust > Desaturate

The image was scanned from a color transparency and converted to black and white with the Desaturate command. This print echoes the feeling of the original image, which had open shadows and a fairly smooth tonal range.

■ Image 2

Steps: Image > Adjust > Levels

Burn tool

The Levels dialog box was opened and the tonal scale was compressed. This interpretation altered the sense of light in the image and the apparent time of day the photo was taken. However, the hills in the foreground at the bottom left side of the image picked up excessive contrast. This was controlled with the Burn tool set for Highlights, Exposure: 30%.

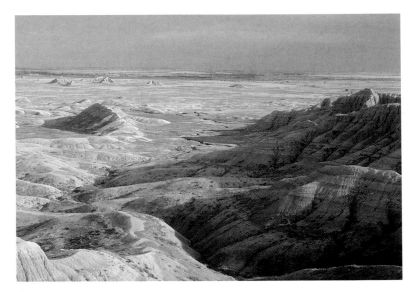

Image 1

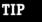

TIP

When increasing contrast overall keep an eye out for areas that may lose highlight detail. In this example, the tonal shift left a bright spot in the corner of the image, a most distracting element. Burning in the corners and edges of an image "encloses" the image and leads the viewer's eye to the center.

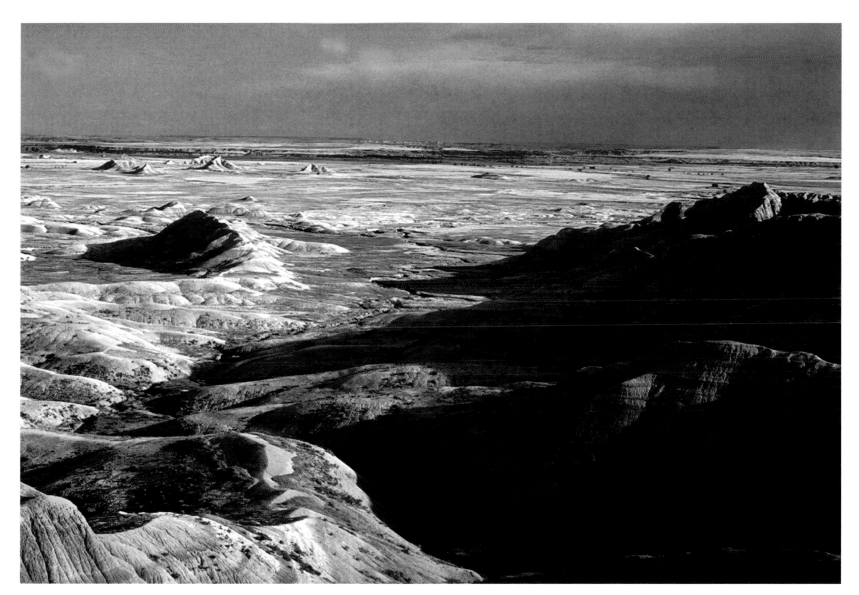

Image 2

■ High Contrast:

Increase image contrast using Levels and Unsharp Mask

Comments: High contrast is easily attained using the Levels commands. Adding extra touches to this image using the Unsharp Mask filter gave it a gritty feel.

Image Source: 35mm black-and-white negative

Scan: Photo CD

File Size: 4.5 MB

■ Image 1

Steps: File > Open > 4.5 MB

This is the image as scanned. The tonal range of this image was fine, but a high-contrast rendition was desired.

■ Image 2

Steps: Image > Adjust > Levels
Filter > Sharpen > Unsharp Mask

In the Levels dialog box, the black and white sliders were compressed to raise image contrast. To add an even more expressionistic feel, Unsharp Mask was chosen from the Filter menu with the Amount of sharpening set at 100% with a Radius of 18. Threshold was kept at 0. Using a high Radius setting added a harsh edge to the final image.

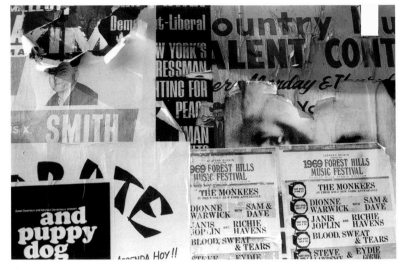

Image 1

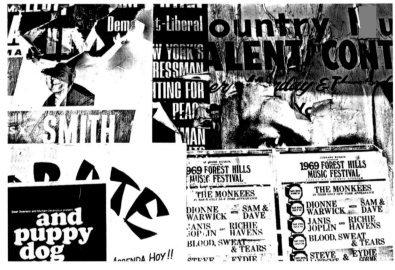

Image 2

TIP

When working with the Unsharp Mask filter, experiment with the Radius settings and preview the results. Generally, a Radius of 1 is chosen to produce subtle effects for most images; however, working with higher numbers can create images with a hard-edged feel and open up the door to some fascinating image effects.

■ High Contrast:
Apply line drawing effects with contrast controls

Image 1

Comments: The initial impetus for making this image came from recognizing the graphic potential of the lines in the snow. Unfortunately, exposure was "blown," and the snow was rendered as a gray mass, which lost any possible graphic effect. The translation back to high contrast allowed the original intent of the image to be realized.

Image Source: 35mm black-and-white negative

Scan: Photo CD

File Size: 1.5 MB

■ Image 1

Steps: File > Open > 1.5 MB

The original photograph is of a small plant in the snow; the scene was underexposed, rendering the snow gray. The design is intriguing, but requires manipulation to make it effective.

■ Image 2

Steps: Image > Adjust > Levels
Image > Adjust > Brightness/Contrast

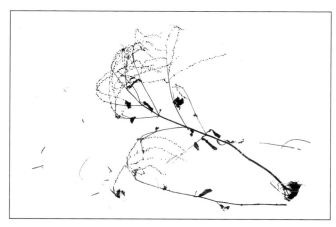

Image 2

The image was manipulated in the Levels dialog box using the gray and white sliders. The white slider was moved toward the gray so that the dull gray background disappeared. Contrast was then enhanced with the Brightness/Contrast controls. As changes were made, they were previewed on screen.

■ Image 3

Steps: Filter > Sketch > Chalk & Charcoal

For an extra touch the image was manipulated with the Chalk & Charcoal filter. This thickened the lines on an "art paper" background.

Image 3

TIP

Compressing the tonal scale and creating a high-contrast image eliminated the murky gray background.

■ High Contrast:
Explore high-contrast options

Comments: There are many routes to high-contrast imagery and various levels of control that can be used to achieve the effect. Use each according to the image chosen, and experiment to see which yields the look you desire.

Image Source: 35mm black-and-white negative

Scan: Photo CD

File Size: 18 MB; after grayscale conversion, 6 MB

■ Image 1

Steps: File > Open > 18 MB
 Image > Mode > Grayscale

This subject is form defined by texture, a good candidate for a high-contrast rendition. The original image shows a good range of tonal values.

■ Image 2

Steps: Filter > Sharpen > Unsharp Mask

One way to add contrast is through use of the Unsharp Mask filter. Normally, this filter is applied to sharpen a "soft" scan; typically, settings in the dialog box are Amount: 100–200%, Radius: 1, and a Threshold setting of 0. This usually snaps up an image, creating an effect similar to the darkroom method of treating a cold-tone photographic paper in a 1:20 dilution of Rapid Selenium toner.

However, the image shown here was created by applying 300% sharpening with a 35 pixel radius; Threshold was kept at 0. The Radius setting defines the range of pixels sharpened from an edge, thus a higher setting results in increased contrast.

■ Image 3

Steps: Image > Adjust > Levels

Another way to increase contrast is to adjust the Levels. High contrast is actually a compression of tonal scale, that is, squeezing the black and white points closer together. That's what was done here, with a black point setting of 90 and a white point setting of 95; the gray setting was slid to 0.69. This eliminated shadow detail and brought the brightest highlights beyond textural rendition.

TIP

Decide how you would like the image rendered and then apply the appropriate controls. Using the Levels slider controls to compress the tonal scale yields deep black, "hot" white, and a few grays in-between. For a high-contrast look that retains some details in the shadow areas, choose Sharpening with a fairly high Radius setting. Either way, use the Preview feature to check the effect before applying it to the image.

Image 1

Image 2

Image 3

■ Colorization

Explore various colorizing options

Image Sources: Medium-format black-and-white transparency; 35mm black-and-white negative

Scans: Photo CD

File Sizes: 4.5 MB

Steps: Image > Adjust > Hue/Saturation
Colorize

There are many ways to colorize an image, and the options used depend upon the effect you desire. The initial step for each image was to apply the Image > Adjust > Hue/Saturation command and check Colorize in the dialog box. This prepared the black-and-white images for colorization.

■ Image 1

Steps: Select > All
Color palette
Edit > Fill

This use of a single color is more similar to toning than colorizing. The slate gray-blue color, chosen to emulate a threatening sky, was applied over the entire image.

■ Image 2

Steps: Color palette
Magic Wand tool
Edit > Fill

This imaginative colorization, which began as a medium-format black-and-white slide, was created using a "select-and-fill" technique. Areas to be colored were selected with the Magic Wand tool set at a tolerance of 5. (A higher tolerance setting would have included larger areas of the image in the selection.) The Color palette was used to pick fill colors, and frequent color changes were made. After a fill color was selected, the Edit > Fill dialog box was called up. The opacity of the fill colors was changed (ranging from 20% to 50%) for different parts of the image.

Options:

1) Simplify this colorizing technique by using only two colors. Assign Foreground and Background colors using either the Color palette or Color picker. Fill selected areas with one color or the other by toggling between the boxes. Adjusting the opacity in the Fill dialog box varies the color depth and intensity, even though only two colors are used.

2) Expand the color rendition by bringing the already-colorized image into Image > Adjust > Levels to manipulate the contrast and brightness of the scene.

Image 1

Image 2

■ Colorization

Create duotone images that resemble toned photographic prints

Comments: Duotones differ from colorizing in that the whites and highlights remain clear, much as they do in traditional photographic toning. Colorizing tends to "wash" color over the entire image, though the highlights can be cleared later with the Sponge tool. Duotone files can also be produced for publication work; always check first with your printer on file setup specifications before submitting it to them.

Image Source: Medium-format color transparency

Scan: Photo CD

File Size: 18 MB; cropped, 13.9 MB

Steps: File > Open > 18 MB
 Cropping tool
 Image > Mode > Grayscale
 Image > Mode > Duotone

After opening the file, this square-format image was cropped to a rectangular shape. It was then converted to Grayscale mode, then Duotone mode. When the Duotone mode is called up, a dialog box appears from which you can choose a wide variety of color variations. These variations are chosen from the color palette and can yield colors reminiscent of conventional photographic toners or entirely new color combinations. You can also vary the intensity of the color by adjusting the curves in the Duotone dialog box. A number of software programs, including Photoshop, have preset duotone curves from which you can choose. The toner effects chosen here resemble:

■ **Image 1** A 1:3 dilution of selenium toner on cold-tone paper.

■ **Image 2** Gold toner on cold-tone paper resulting in a rich blue-black.

■ **Image 3** Sepia toner on cold-tone paper; this can be made to yield a more gold or brown rendition depending upon the color and curve selected.

Image 1

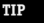

TIP

When creating duotones, always choose the darker color (usually black ink) as the "first ink" in the dialog box, as this will result in better image saturation. You can also create tritones and quadtones in the same basic manner, if desired.

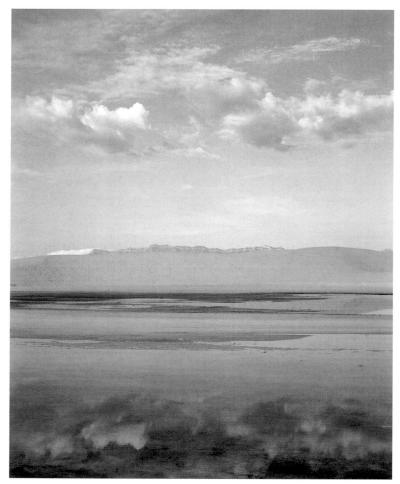

Image 2

Image 3

■ Colorization:
Tone with the Hue/Saturation command

Comments: Virtually any color can be used for toning, although many imagers tend to use colors such as blue, sepia, and brown, which are associated with chemical toning. Overall colorization covers the entire image in color; a few deft strokes with the Sponge tool helps clear highlights, thus emulating the photographic toning effect.

Image Source: 35mm black-and-white negative

Scan: Photo CD

File Size: 4.5 MB

Steps: File > Open > 4.5 MB
 Eyedropper tool
 Airbrush tool

The initial steps taken with this image involved retouching. Spots were eliminated in two ways: using the Eyedropper tool to match tones around the area to be retouched and the Airbrush tool to cover the defects.

■ Image 1

Steps: Image > Adjust > Hue/Saturation
 Color palette
 Edit > Fill

The image was prepared using Image > Adjust > Hue/Saturation with the Colorize option chosen in the dialog box. This blue was picked from the Color palette to emulate the effect of traditional photographic toner. The color was applied over the entire image using Edit > Fill with the opacity set low.

■ Image 2

Steps: Toning Tools Options palette > Sponge tool > Desaturate
 Image > Adjust > Levels

After applying yellow to the image using the same steps as described for Image 1, the Sponge tool was chosen from the Toning Tools Option palette. The Sponge tool was used to clear color from various areas of the print. Desaturate was chosen from the Sponge tool palette and the worked areas reverted to background gray. The Sponge tool can be used to break up the overall color cast of images that have been "toned" using the colorize option. It is most effective when applied to highlights. Finally, the contrast was raised and the image was darkened using the Levels dialog box to create a more dramatic effect.

TIP

If you find specific colors you like for colorizing and toning, store the settings so that you can call them up again. This is particularly important if you plan to create sets of prints for portfolios or limited editions.

Image 1

Image 2

■ Colorization:
Colorize selections with the Hue/Saturation command

Comments: While this approach gives a "block" look to colors, it is an interesting way to colorize images. The technique is similar to split toning, in which certain areas of the image are masked off with frisket to allow for separate treatment.

Image Source: 35mm black-and-white negative

Scan: Photo CD

File Size: 4.5 MB

Steps: File > Open > 4.5 MB

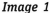
Image 1

■ Image 1

The image as printed from the scan.

Steps: Image > Adjust > Hue/Saturation
Color palette

To test colors for each section, the Colorize option was checked in the Hue/Saturation dialog box, and a color was picked out of the Color palette for the sky. A test print was made, and the settings were noted. The same was done to pick the color for the buildings and foreground.

■ Image 2

Steps: Lasso tool
Color palette
Edit > Fill
Select > Inverse
Color palette
Edit > Fill

Using the Lasso tool, the sky and ground were separated; the ground portion was selected, and the previously selected color was applied using Edit > Fill. Using Select > Inverse, the sky portion was selected, and the sky color was added in the same way.

Steps: Image > Adjust > Levels
Lasso tool
Color palette
Airbrush tool

For the final steps, the image was lightened slightly using the Levels command. The touch of green in the image was added by selecting the area around the plants with the Lasso tool. Green was picked from the Color palette as the Foreground color and applied with the Airbrush tool at 20% opacity.

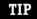

> ### TIP
>
> *When selecting colors for this technique, consistent intensities and Fill opacities produce a more cohesive look. The effect is similar to block printing, in which colors are added overall rather than to selected areas.*

Image 2

■ Colorization:

Colorization with the Paint Bucket tool and Fill command

Image Source: 35mm black-and-white negative

Scan: Photo CD

File Size: 4.5 MB

■ Image 1

Steps: File > Open > 4.5 MB
Magic Wand tool
Color palette
Edit > Fill

This rendition was created using the Magic Wand tool (Tolerance: 5) to select areas that were then filled in using the Edit > Fill command. The advantage of this approach is that you can vary the color intensity by adjusting the Fill opacity. To create this subtle effect, levels from 10% to 30% were used. This covered the image with a thin coat of "paint."

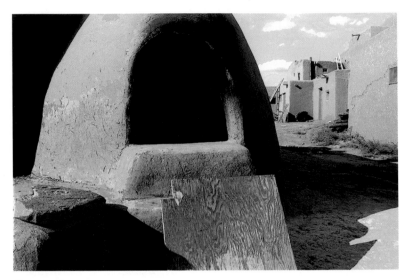

Image 1

■ Image 2

Steps: Magic Wand tool
Color palette
Paint Bucket tool

This Fauvist approach was created by using the Magic Wand tool to select an area of tonality, then picking a color from the palette to replace it. The Paint Bucket tool was used to fill the selected areas. This approach creates a more painterly look to the scene.

Image 2

<div style="border:1px solid">

TIP

When colorizing select areas, you can save time by designating two colors as Foreground and Background colors, and then toggling between them to fill selected areas with those two colors. Then reassign the Foreground and Background colors and fill other areas. This saves you from having to go through the color selection process every time.

</div>

■ Colorization:
Define a subject through selective use of color

Comments: This technique can be used with any color source image.

Image Source: 35mm color transparency

Scan: Photo CD

File size: 4.5 MB

Steps: File > Open > 4.5 MB
 Lasso tool
 Select > Inverse
 Image > Adjust > Desaturate

To highlight a specific shape, subject, or form within an image you can isolate that subject and drop color out from the rest of the image. First, the mask in the foreground was selected with the Lasso tool. Then, the Select > Inverse command was used to make the background the active selection. The Image > Adjust > Desaturate command was used to render the selected area as monochromatic.

TIP

While the selected area is still active after applying the Desaturate command, judge whether additional manipulation would enhance the overall effect. For example, additional alterations to contrast and brightness may be desired.

Comments: Retouching is a time-honored craft within the photographic trade, and retouchers work for many years to perfect their craft. While digital retouching is eminently easier, especially when it comes to techniques such as airbrushing, it takes practice to produce good results.

Image Source: 35mm black-and-white copy negative of a print

Scan: Photo CD

File Size: 4.5 MB

■ Image 1

The copy negative of this old image reveals extreme tear damage and print flaws. It is also low in contrast.

■ Image 2

Steps: File > Open > 4.5 MB
Cropping tool
Filter > Noise > Dust & Scratches

The image was cropped to center the woman's face. An attempt was made to remove the defects using the Dust & Scratches filter. This can solve problems with some old photos by modifying the damage through unsharpness, but here, the point at which the scratches dissolved resulted in excessive blur. However, this gave us a clue as to where to begin the restoration process.

■ Image 3

Steps: Lasso tool
Quick Mask mode
Airbrush tool
Select > Inverse
Filter > Blur > Gaussian Blur

To eliminate the scratches and grain in the background, the head and shoulders were selected with the Lasso tool. Quick Mask mode was employed and the selection was refined with the Airbrush tool. The selection was then inverted to make the background "active," that is, so it would be affected by changes. A Gaussian Blur filter was applied to the background at 60%. This completed the background nicely.

■ Image 4

Steps: Select > Inverse
Image > Adjust > Levels
Airbrush tool
Eyedropper tool

The selection was again inverted so that the face became the active area. The image was brought into Levels to raise the contrast, and the Airbrush tool was employed to begin the process of removing the grain and scratches from the face. Tones were picked using the Eyedropper tool to match adjacent density. This image shows the beginning of the buildup.

■ Image 5

The Airbrush tool was used to provide a more even spread of tones, using the previous image (4) as a guide. Some shadow and grain were left around the features to provide modeling on the face.

■ Image 6

Steps: Image > Adjust >
Hue/Saturation
Color palette

The final image was then brought into Image > Adjust > Hue/Saturation to provide a sepia-toned effect.

TIP

The Dust & Scratches filter is an excellent way to remove blemishes from prints, but be aware that a slight blur or loss of sharpness occurs when it is employed. You can select areas for spotting, then apply the filter as required, or you can employ this filter to large, undetailed areas, as shown here.

■ Special Effects:
Solarization

Comments: Solarization, also known as the Sabbatier effect, is accomplished in the darkroom by briefly exposing a partially developed image to white light. The solarized print usually needs to be bleached, a process that utilizes potassium ferricyanide to open up areas that have gone too dark. The effect of solarization is random and very unpredictable; often, more than a few sheets of paper are expended to get it right. In the computer environment the process is somewhat less random (which does take some of the mystery out of the technique) but certainly much easier.

Image Source: 35mm black-and-white negative

Scan: Photo CD

File Size: 4.5 MB; after grayscale conversion, 1.5 MB

■ Image 1

Steps: File > Open > 4.5 MB

Image > Mode > Grayscale

This image was chosen for solarization because of its potential for producing exciting effects in line and texture.

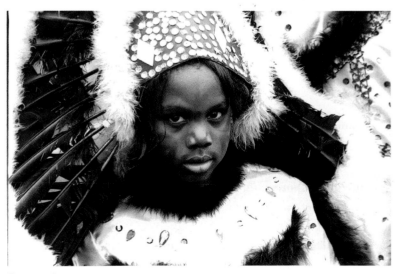

Image 1

■ Image 2

Steps: Filter > Stylize > Solarize

The Solarize filter was applied. Solarization is a partial reversal of tonality, especially noticeable in tonal borders. The effects are often unpredictable, as the changes seem to occur at random. The filter changes some but not all tonal areas, with an emphasis on edges.

■ Image 3

Steps: Image > Adjust > Levels

To heighten the effect, the solarized image was manipulated using the Levels control. Using point selection in Levels, the white point was placed on the forehead and the black point on the middle-gray feather fringes of the costume. This raised the contrast and cleared the image of its gray cast.

TIP

After the Solarize filter is applied, play with the Levels control to accentuate the effect. Often, increasing contrast (to get a deep black and true white) will do the trick.

Image 2

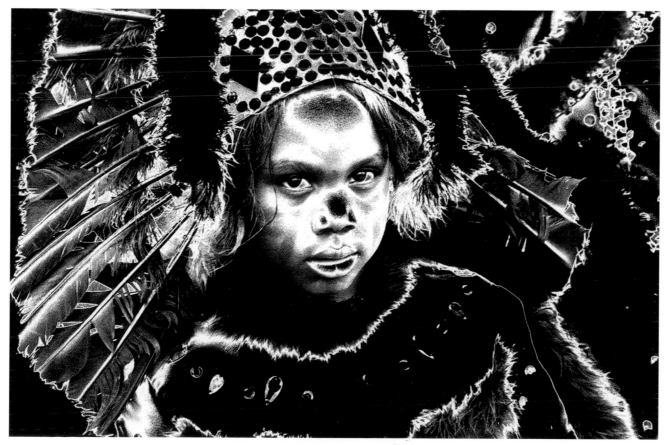

Image 3

■ Special Effects:
Enhance grain

Comments: The idea of using grain enhancement for this image began with the initial choice of using a high-speed, grainy film as the recording medium. In the darkroom, a grain-screen negative can be sandwiched with the original image. Here, a digital filter that adds grain was used to "pop" the grain. The advantage here is that the grain pattern (uniform or random) and the degree of graininess can be set at the touch of a button. It's as if you have one hundred grain filters from which to choose.

Image Source: 35mm color negative

Scan: Photo CD

File Size: 6 MB; after grayscale conversion, 1.5 MB

■ Image 1

Steps: File > Open > 6 MB

Image > Mode > Grayscale

This image taken on high-speed film already exhibits grain, but is a bit too flat. The grain is "swallowed up" by the low-contrast rendition.

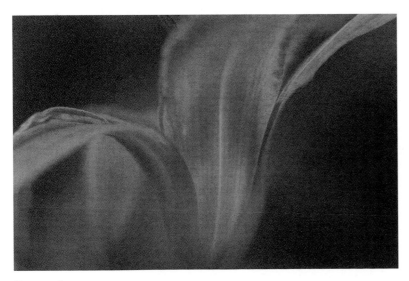

Image 1

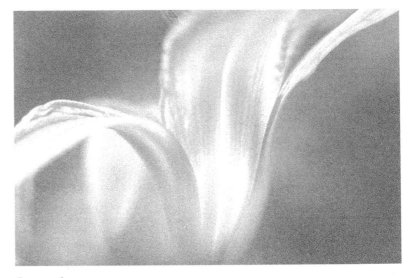

Image 2

■ Image 2

Steps: Filter > Noise > Film Grain

Image > Adjust > Levels

The dialog box for this filter allows you to set the degree of graininess. The effects were previewed and then applied when the desired effect was achieved.

■ Image 3

Steps: Filter > Sharpen > Unsharp Mask

The Unsharp Mask filter enhances the grain even more (as does any sharpening); the setting was 150% with a Radius of 1, and Threshold set at 0.

Steps: Image > Adjust > Brightness/Contrast

With digital imaging, as with darkroom work, increasing contrast enhances grain. The Brightness/Contrast dialog box was opened and, based on the preview, the controls were set at Brightness: -71 (to darken the image) and Contrast: +52 (to add contrast).

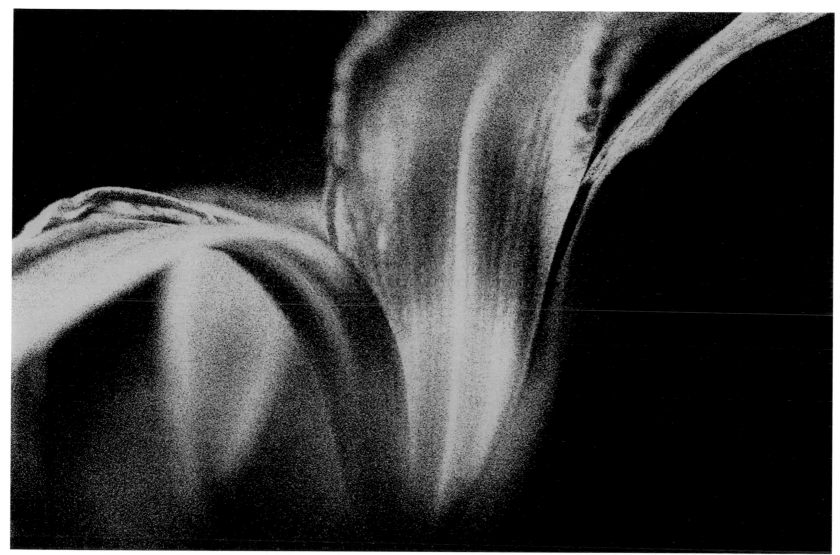

Image 3

Comment: The aim is to break up highlights and soften the image overall (through diffusion, not unsharpness). To achieve this effect in the darkroom, the positive transparency first has to be converted to a negative. The image is then exposed through a gel or glass sheet smeared with various thicknesses of petroleum jelly and printed on a low-contrast-grade paper. However, here the degree of the effect is easily controlled by the options on the Diffuse Glow filter dialog box.

Image Source: Medium-format color transparency

Scan: Photo CD

File Size: 18 MB; after grayscale conversion and cropping, 3.2 MB

■ Image 1

Steps: File > Open > 18 MB
 Image > Mode > Grayscale
 Cropping Tool

After grayscale conversion the image was cropped, which cut the working file size down to 3.2 MB. A work print was made from the scanned image. The print was crisp, but the white petals on the tree were still too gray. The subject matter—light coming through petals and leaves—lends itself to diffusion (scattering of highlight) effects. Because diffusion works most effectively on high-key images (a highlight bias with few dark tones), the decision was made to create a lighter print.

■ Image 2

Steps: Image > Adjust > Levels

Using the Levels control and working with the sliders, we made the overall image lighter with a setting of 5 (black), 1.63 (mid-tones), and 143 (white). This opened up the image and created a brighter impression. The changes were previewed as they were made.

■ Image 3

Steps: Filter > Distort > Diffuse Glow

From the Filter palette, Diffuse Glow was selected. This works mainly on the highlights, with selections for Grain, Glow, and Clear effects. Because there are black areas in which definition should be retained, the selections Grain: 2, Glow: 3, and Clear: 18 were made. The image effect was previewed before being saved. The final print shows the desired diffusion effect.

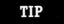

TIP

You might also want to explore Underpainting, Blur, and the Sponge tool as ways to enhance diffusion. Each has its own distinct effect and should be used according to image content.

Image 1

Image 2

Image 3

■ Special Effects:
Enhance image with the special effects filter Ink Outlines

Comments: Technique should not overwhelm the subject matter. In this image the fantastic plumage of the bird lent itself to interpretation, enhanced by the increase in contrast. Placement of the white and black points was key here, as it was important not to lose detail in the subject-defining head and neck of the bird.

Image Source: 35mm color transparency

Scan: Photo CD

File Size: 6 MB; after grayscale conversion, 1.5 MB

■ Image 1

Steps: File > Open > 6 MB
 Image > Mode > Grayscale

This "flat" scan cried out for increased contrast. The lines and forms lent themselves to special effects interpretation.

■ Image 2

Steps: Image > Adjust > Levels

Contrast was increased using the Levels controls, and black and white point selection. The brightest area in the scene, the body of the bird directly behind its head, was chosen as the white point. The black point was selected from the dark background. The effect was previewed prior to clicking OK.

■ Image 3

Steps: Filter > Brush Strokes > Ink Outlines

Ink Outlines was chosen from the Filter menu. Brush stroke, size, and contrast options were previewed in the Filter dialog box. A subtle effect was chosen, one that emphasized the form and line play of the image.

Image 1

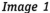

TIP

When working with special effects filters it is important to preview the effect prior to applying it to the image. Processing time can be fairly long when elaborate effects are used. Not previewing what might be an unsatisfactory result will waste time and energy. Filters and other commands have options that allow you to key in the degree to which the effect is applied and then preview the change.

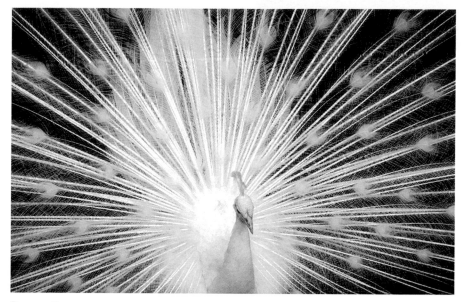

Image 2

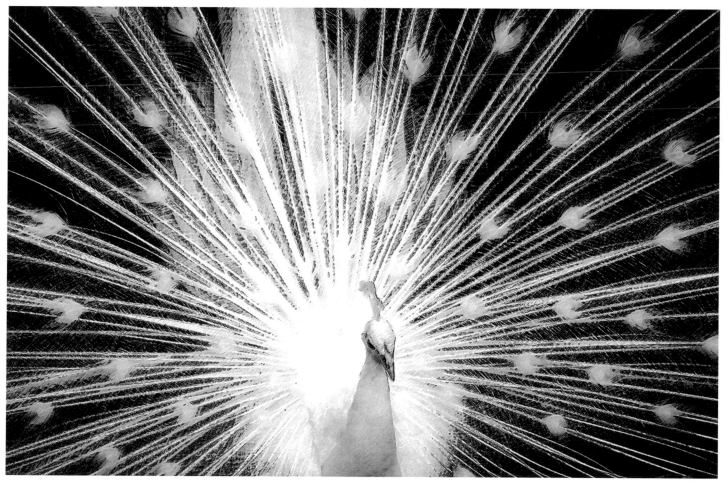

Image 3

■ Special Effects:
Enhance a scene using light and diffusion

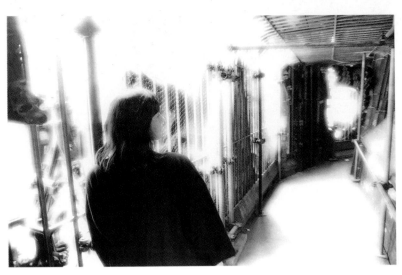
Image 2

Comments: An image is often more a remembrance than a documentation of a moment. What was remembered here was the beautiful quality of light and how it felt to walk through the space. The effects were applied to emulate that feeling; details are lost, but the emotions are brought forth in the process.

Image Source: 35mm black-and-white negative

Scan: Photo CD

File Size: 4.5 MB; after grayscale conversion, 1.5 MB

■ Image 1

Steps: File > Open > 4.5 MB
Image > Mode > Grayscale

When the photo was made, light was streaming through the side grating and end point of a walkway of a cathedral under construction. The light presence was overpowering and created a feeling of walking through a tunnel of brightness. The exposure dampened this effect and recorded more detail than desired.

■ Image 2

Steps: Image > Adjust > Levels
Filter > Distort > Diffuse Glow

To bring back the original feeling of the moment, the image was first lightened using the controls and preview in the Levels dialog box. The sliders were manipulated to open up the scene; some details were obscured, but this was just what was wanted here. To heighten the effect, Diffuse Glow was chosen, and the degree of application was manipulated and previewed to match the scene as visualized when photographed.

Image 1

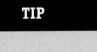
TIP

Diffuse Glow is a powerful filter that, when over-applied, can overwhelm the image. The options offered in its dialog box allow you to control the effect very carefully. This goes for most special effects, so make sure you preview the effect before application. In your spare time you might want to make a catalog of various effects for future reference; often, what may "work" in color is just so much window dressing in black and white.

■ Special Effects:
Create edge effects that echo a pencil drawing

Comments: Compare these effects done digitally to what you'd have to do in the darkroom—make a high-contrast interpositive, mask it with a high-contrast internegative—that takes about six steps including exposure and development of film. You can see why such images are optimally created in the digital realm.

Image Source: 35mm black-and-white negative

Scan: Photo CD

File Size: 4.5 MB

■ Image 1

Steps: File > Open > 4.5 MB

The wheel on this old harvester is a prime candidate for special effects treatment. As scanned and printed it displays a wide range of tonal values.

Image 2

■ Image 2

Steps: Filter > Stylize > Find Edges

The Find Edges filter dialog box allows for experimentation to determine the right combination of effects for your particular image.

Image 1

> ### TIP
>
> *Images with inherent graphic appeal might be prime candidates for this filter treatment. As a general rule, apply special effects filters before you work with contrast, retouching, or tonal controls.*

■ Special Effects:

Various special effects filters

Comments: Filters are special effects generators that provide a wide range of visual tricks. But because they are tricks, they should be used sparingly. Experimentation is key, and good taste is the best guide.

Image Source: Polachrome 35mm black-and-white transparency

Scan: Photo CD

File Size: 6 MB; after grayscale conversion, 2 MB

■ Image 1

Steps: File > Open > 6 MB

Image > Mode > Grayscale

This ghostly image of figures used by puppeteers was chosen because it lends itself to graphic interpretation.

Image 1

■ Image 2

Steps: Filter > Brush Strokes > Sumi-e

The Sumi-e filter creates a feeling of motion and enhances the spooky mood of the image. The options include Stroke Width, Stroke Pressure, and Contrast. Settings of 8, 2, and 14 respectively were applied after first varying and previewing the effects.

■ Image 3

Steps: Filter > Sketch > Conté Crayon

Image > Adjust > Levels

An alternative image was created by trying the Conté Crayon filter with the Sandstone option chosen. True to its name, this added texture to the figures and reinforced their sculptural quality.

The image was then brought into Levels, where the contrast was increased by placing the white point on the highlight and the black point on the background. The midtone slider was manipulated to raise the overall contrast.

TIP

You can save time when using filter effects by selecting a small portion of the image for preview. Also, remember to convert scans of black-and-white images from RGB to Grayscale mode before starting to work the image.

118

Image 2

Image 3

Comments: For most image contrast and tonal adjustments, the Levels dialog box works well. For customized settings and more control, the Curves command is sometimes preferred. Curves is a toy box of special effects. Virtually any tonal relationship can be obtained; the shape of the curve defines those relationships. Here, the shape has been greatly distorted to achieve this special effect.

Image Source: Medium-format black-and-white negative

Scan: Photo CD

File Size: 4.5 MB

■ Image 1

Steps: File > Open > 4.5 MB

This image has excessive contrast due to overexposure. Though contrast controls could have been applied to create a "straight" print, the abstract subject matter lent itself to a more creative interpretation. There are intriguing graphic possibilities suggested by the abstract shapes and lines on the rock.

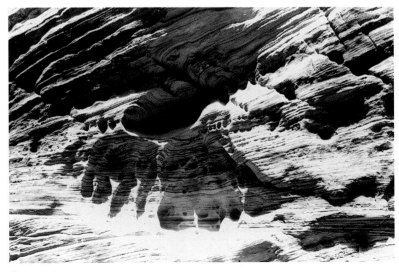

Image 1

■ Image 2

Steps: Image > Adjust > Curves

The Curves dialog box allows you to play with the actual curve shape of the image and can offer more of a sense of play than other controls. The curve was shaped to skew the tones and cause partial reversal, which approaches a solarization effect. The tonal edges in the dark values were accentuated, while middle values picked up textural effects.

Image 2

TIP

When working in Curves, the bottom portion of the curve (lower left) represents the shadow portion of the scene, and the upper portion represents the highlights. You can invert the curve at any time, if desired. As with the Levels command, Curves has black, white, and midtone eyedroppers to target areas in the image. You can save a particular curve setting for use on other images.

■ Special Effects:
Posterization

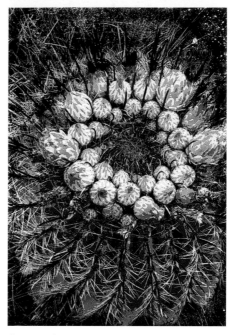

Image 2

Comments: Even if an image starts out "flat," you have an opportunity to work with its elements to emphasize forms and composition. This opens possibilities that may have been overlooked or ignored upon first inspection.

Image Source: 35mm black-and-white negative

Scan: Photo CD

File Size: 4.5 MB

■ Image 1

Steps: File > Open > 4.5 MB

This barrel cactus has a wonderful variety of textures and forms, but the exposure mutes the textural differences and graphic potential.

■ Image 2

Steps: Lasso tool
Image > Adjust > Levels
Burn tool

First the area around the cactus was selected with the Lasso tool and made darker in the Levels command dialog box. Further edge burning was done with the Burn tool at 40% opacity.

Steps: Select > Inverse
Image > Adjust > Posterize
Dodge tool

The selection was inverted so the cactus itself could be worked. The Posterize application was chosen. The number of Levels was set at 6, producing dramatic results. To open up the buds and center of the cactus, the Dodge tool was applied and set at Midtones, with 30% opacity.

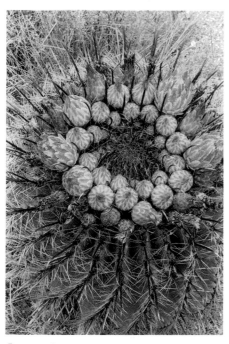

Image 1

TIP

Posterization can be applied in degrees. When you open up the Posterize dialog box you can key in the number of Levels from 2 to 255 and preview the results.

■ Special Effects:
Special effects using the Curves command

Comments: While basic imaging controls can always be used to enhance contrast and tonality, the ease with which other possibilities can be explored is a real advantage in the digital realm. As you make the creative tour you'll see which of these controls works best for you and begin to understand that opening up the graphic potential of every image is what this process is all about.

Image Source: 35mm color transparency

Scan: Photo CD

File Size: 4.5 MB

■ Image 1

Steps: File > Open > 4.5 MB

Image > Adjust > Desaturate

The original image was very warm and rich. After the Desaturate command was applied, the values translated to a set of lush grays. The design and line play in the image leads to numerous interpretations.

■ Image 2

Steps: Image > Adjust > Curves

Burn tool

To explore the possibilities, the Curves control was opened; using the mouse, the curves were twisted and bent in various ways. Shadows were made white; middle grays gained contrast by separating the subtle values into dark and light tones. To accentuate contrast further, the Burn tool was used on the shutters, open windows, and lamp post.

TIP

Graphic work such as this is done in stages. The first stage is to decide upon the direction the work will take. Look at the overall approach before applying the first set of controls. Refinement comes afterward, when minor touches are used to enhance the chosen effect. Here, the Burn tool was essential to completing the look of the image.

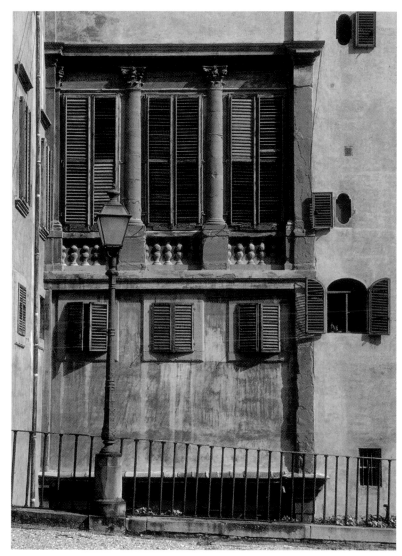

Image 1

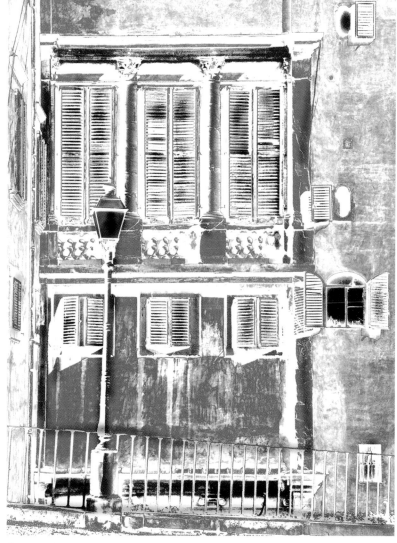

Image 2

■ Special Effects:
Isolate or silhouette part of a scene

Comments: Silhouettes are commonly used by product photographers and printers to clean up backgrounds and/or isolate a product shot for later inclusion in an ad or brochure. The technique is called "masking." As seen here, it can also be used to produce some interesting graphic effects.

Image Source: 35mm color transparency

Scan: Photo CD

File Size: 4.5 MB

■ Image 1

Steps: File > Open > 4.5 MB
Image > Adjust > Desaturate

This close-up shot of the inside of a watch has intriguing possibilities. After study, it was decided to isolate part of the subject to find hidden forms within the overall scene.

■ Image 2

Steps: Image > Adjust > Levels
Lasso tool
Quick Mask mode
Airbrush tool
Image > Adjust > Curves

Contrast was increased using the Levels dialog box in order to emphasize forms and shapes. The Lasso tool was used to select areas that would be eliminated. The Quick Mask mode was employed, and then the Airbrush tool was used to refine those selections. The selected areas were then manipulated in the Curves dialog box and previewed. While a background of any tonal value might have been chosen, the black surround with a hint of white was the most graphically appealing solution.

Photo by George Schaub, Sr.

Image 1

Image 2

■ Special Effects:
Work with the Move and Gradient Fill tools

Comments: When you double-click on the Gradient Fill tool you can choose either a Linear or a Radial Fill. The former gradates from one point to another as defined by your drag, while the latter creates a gradient from the center, radiating outward in all directions. Linear Fill was chosen here. You can also choose the opacity of the fill. Gradient Fill can be applied to a selected area, as seen here, or to the entire image as a background, in which case it would work as a Transparent Layer.

Image Source: 35mm black-and-white negative

Scan: Photo CD

File Size: 4.5 MB

■ Image 1

Steps: File > Open > 4.5 MB

 Image > Adjust > Levels

After the image was opened it was brought into Levels and the contrast was raised. These people are looking at a sculpture in a museum; the figure in the foreground ducked down as the picture was made, creating a feeling of dance around the piece.

■ Image 2

Steps: Image > Posterize

To enhance the abstract mood, the image was posterized. When you open the Posterize command you must set Levels in the dialog box. Several Levels settings were previewed on screen; a setting of 4 was used for this image.

■ Image 3

Steps: Magic Wand tool

 Move tool

 Gradient Fill tool

The Magic Wand tool, with a tolerance setting of 3, was used to select each figure. After a figure was selected, the Move tool was placed on the figure, and the figure was dragged to a new position. The default Background color was exposed by moving the figure. This created a white silhouette in the place where the figure had been. The white silhouette was then selected using the Magic Wand Tool. The Gradient Fill tool was chosen, and the defining area for the fill was chosen by dragging it the length of the white silhouette, then releasing the mouse. All three figures were moved a number of times.

TIP

The Move tool can be used to clone figures by working with selection tools. You can use the Magic Wand or work freehand with the Lasso tool to create those selections.

Image 1

Image 2

Image 3

■ Special Effects:
Partial reversal of tones

Comments: The decision to go with either a "straight" or highly interpretive rendition of a scene depends upon many factors. Your state of mind, feelings the image evokes, and the potential for effective application of special effects all play a part. Here, the form and presence of the dead tree seemed to call for more than tonal adjustments, and partial reversal seemed to speak directly to the energy of the scene.

Image Source: 35mm black-and-white negative

Scan: Photo CD

File Size: 4.5 MB

■ Image 1

Steps: File > Open > 4.5 MB

This fallen tree created a ghostly figure, which lent itself to a special interpretation.

■ Image 2

Steps: Image > Adjust > Brightness/Contrast

To begin, the overall image was given a bit more contrast using the Brightness/Contrast dialog box. This is a simple slider control, the effects of which are previewed on the screen.

Steps: Lasso tool
Quick Mask mode
Airbrush tool
Image > Invert

The form of the tree was then selected with the Lasso tool. Then Quick Mask mode was chosen and refinements were made to the mask using the Airbrush tool. The tones in the selection were then reversed (making the selection into a negative image) by choosing the Invert command from the Image menu.

TIP

The decision to raise or lower contrast should be made within the context of the overall "feel" of the image. While the tonal values in this image were not objectionable, a higher-contrast rendition of the unreversed section seemed to blend more effectively with the applied special effect.

Image 1

Image 2

Comments: The Transform commands can be applied to very specific image manipulation techniques, such as rotation, skewing, or perspective control. Free Transform uses keyboard shortcuts to access the same commands as the Transform submenu.

Image Source: Medium-format color transparency

Scan: Photo CD

File Size: 18 MB; after grayscale conversion, 6 MB

■ Image 1

Steps: File > Open > 18 MB
 Image > Mode > Grayscale

This classic New England church printed a bit flat; the shapes and details called for some enhancement.

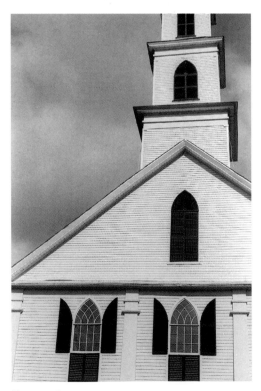

Image 1

■ Image 2

Steps: Image > Adjust > Levels
 Layers > Transform > Scale

The image was lightened using the Levels dialog box. The layer cake effect was made by using the Duplicate Layer command to create three new layers, each containing an image of the church. Each layer was activated and scaled individually. After choosing the Scale command, the Shift key was held down while the upper right corner handle was dragged to scale the image proportionately. The smallest image of the church (the top layer) was then distorted to give it a gothic look. The Scale command was applied, and the handle on the vertical end of the frame was dragged upward without holding the Shift key.

■ Image 3

Steps: Image > Posterize

The final touch was made by posterizing the image (Levels: 6) to create a line drawing effect.

TIP

Transform commands are akin to exposing images on a tilted enlarging easel. These techniques can be used to correct unintended distortion or perspective problems, though using them to distort the image can be fun as well.

Image 2

Image 3

■ Special Effects:

Selective special effects control

Comments: The ability to select some areas and affect changes only on the selected areas was key to working this image. Because the truck and its surroundings were to be treated differently, we worked each area as if it were a separate image.

Image Source: 35mm black-and-white negative

Scan: Photo CD

File Size: 4.5 MB

Image 1

Image 2

■ Image 1

Steps: File > Open > 4.5 MB

The image is of a paint truck underneath elevated railway tracks. As scanned, the truck lost some of its luminescence. Lens flare blots out a portion of the supporting I-beams, and the graphic potential of the ironwork and building is muted; this image needs some work.

■ Image 2

Steps: Filter > Sharpening > Unsharp Mask

To increase the image's graphic qualities, it was sharpened to excess using Unsharp Mask with settings of Amount: 150%, Radius: 31 pixels. This added contrast and heightened the visual play in the truck.

Image 3

Image 4

■ Image 3

Steps: Lasso tool
Quick Mask mode
Airbrush tool
Select > Inverse

The truck is just where we want it, but the background needed further manipulation. We selected the truck using the Lasso tool, refined the selection with Quick Mask mode and the Airbrush tool, and went to Select > Inverse. This made the background the active area.

Steps: Image > Adjust > Curves

We then went into Curves and skewed the line until we gained a high-contrast rendition of the background. The preview on the screen allowed us to choose exactly the tonal play we wanted.

■ Image 4

Steps: Airbrush tool

To clean up the image we used the Airbrush tool on Highlight mode, Opacity: 100%, so that we are actually using black ink. White areas on the pavement were filled in, as were some areas on the undercarriage of the truck. Since the truck was not an active selection, it was not affected by "spray" from the airbrush tool.

TIP

When selecting distinct areas of an image and working each one individually, there is usually some need for touch-up in tonal borders and details. Save the touch-up for last, as you can never be exactly sure how certain applied effects will alter the rest of the contrast and tonality of the scene.

Comments: The subject of this photo is quite a magical place, and the effects chosen echoed the visual energy desired. By moving around the image and placing one tonal value in various spots before moving onto the next tonal value, the need to always pick a shade of gray with each selection was eliminated. In all, only 6 different tones were used to fill the 20 selections that were made.

Image Source: 35mm color transparency

Scan: Photo CD

File Size: 4.5 MB

■ Image 1

Steps: File > Open > 4.5 MB
Image > Adjust > Desaturate

The scan of this photograph of a pueblo was somewhat flat, but the potential for tonal play presented itself in the variety of shapes and forms, especially in the stacked arrangement of buildings.

Image 1

■ Image 2

Steps: Lasso tool
Image > Adjust > Levels
Select > None

To begin, the sky and mountains needed darkening, so the area was selected, then adjusted using the Levels dialog box. Afterward, the Select > None command eliminated the selection marquee.

Steps: Magic Wand tool
Color palette
Edit > Fill

The Magic Wand was chosen with a Tolerance setting of 5. It was then moved and clicked in numerous areas; after selection, the color palette was opened by clicking on the Foreground color box in the toolbox. A shade of gray was chosen. Edit > Fill was left on 20% opacity for each fill-in command. The same tone was used to fill several selections. Only about 6 tonal variations were used to create the appearance of variety seen here.

TIP

The Magic Wand is a powerful tool for tonal correction and creation, as it selects every adjacent pixel that matches the tone within the area you click on. The range of the tool is controlled by the Tolerance setting and can be as limited (1) or as broad (up to 255) as you desire.

Image 2

Portraits:
Improve skin tones

Comments: Using only the Threshold setting of the Unsharp Mask filter is a good technique for improving portraits, as it blends the flesh tones nicely. Note that no sharpening was applied. While sharpening is a good idea for many types of images, portraits and certain pictorial scenes are often better off without it.

Image Source: Medium-format color transparency

Scan: Photo CD

File Size: 6 MB; after grayscale conversion, 2 MB

■ Image 1

Steps: File > Open > 6 MB
Image > Mode > Grayscale

This grayscale version of the image was somewhat flat, but experience tells us that a scan such as this offers an ample range of tones with which to play. The aim is to improve flesh tone rendition and create a more pleasing light quality in the scene.

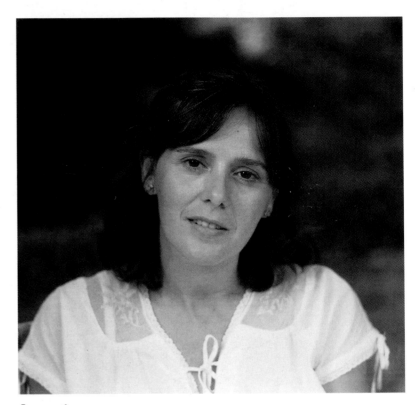

Image 1

■ Image 2

Steps: Cropping tool
Image > Adjust > Levels
Filter > Sharpen > Unsharp Mask

The image was cropped. Then, the Levels dialog box was opened to lighten the flesh tones. Black and white points were maintained at their 0 and 255 settings to retain a full tonal range; the gray level slider was adjusted to lighten the image overall. Unsharp Mask was then applied with settings of Amount: 0%, Radius: 1. However, the Threshold slider was moved to 25, which blended and softened the skin tones.

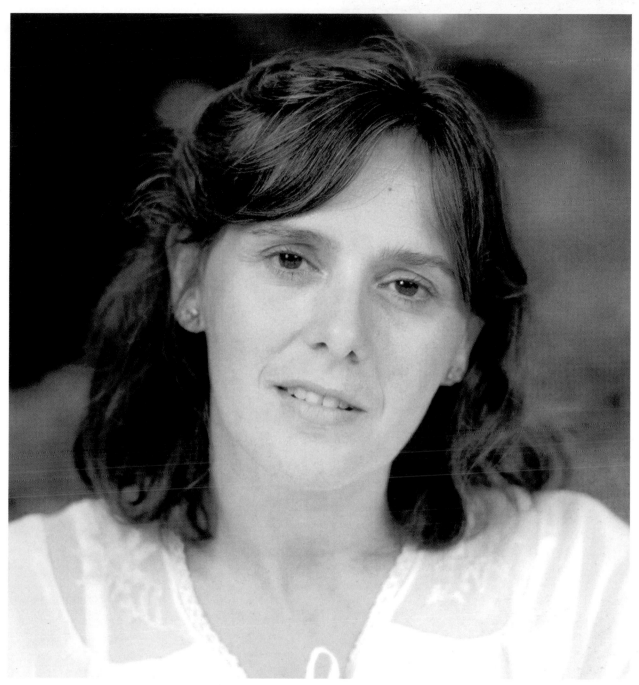

Image 2

Portraits:
Use the Unsharp Mask filter's Threshold setting on portraits

Comments: While most images benefit from sharpening (especially when working from Photo CD scans), portraits and certain scenics may be improved by either ignoring or muting the sharpening effect. This can be done by using the Unsharp Mask's Threshold setting.

Image Source: 35mm black-and-white negative

Scan: Photo CD

File Size: 4.5 MB; after grayscale conversion, 1.5 MB

■ Image 1

Steps: File > Open > 4.5 MB

Image > Mode > Grayscale

Filter > Sharpen > Unsharp Mask

Unsharp Mask was applied at 150%, with a Radius of 2 and a Threshold setting of 0. While these settings sharpened the image, the lines and grain are a bit harsh for the subject.

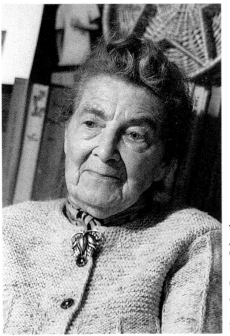

Image 1

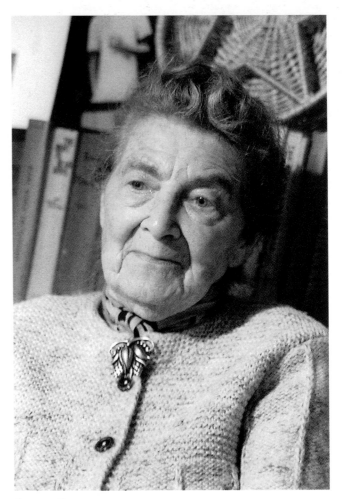

Image 2

■ Image 2

Steps: Filter > Sharpen > Unsharp Mask

To soften the effect yet add sharpness to the image, the Amount and Radius settings were again set to 150% and 2, and the Threshold was increased to 20. This yielded a much more flattering flesh tone.

Photo by Grace Schaub

TIP

If a previewed effect is unacceptable, the original settings in the dialog box can be restored. Holding down the Option key changes the Cancel button to Reset. Clicking here restores the image without closing the dialog box.

Portraits:
Alter a portrait background

Comments: When making portraits in the studio the photographer has complete control of the background. Self-portraits can be a little more difficult. In the computer environment the background can be adjusted by playing with contrast, tone, and even curve shape. While you might do this to "clean up" a background of distracting shadows, the controls here were applied to add an expressionistic touch to the image.

Image Source: 35mm black-and-white negative

Scan: Photo CD

File Size: 4.5 MB

Steps: File > Open > 4.5 MB
 Lasso tool
 Select > Inverse
 Image > Adjust > Levels

This self-portrait was made in 1966. The sidelight casts a shadow on the background. This shadow could be easily removed, but the decision was made to emphasize it. The figure was selected using the Lasso tool, then the selection was inversed so that any changes would affect only the background. The Levels dialog box was called up, and the background was darkened using the slider bars. The selection was inverted again, and the Levels dialog box was used to heighten contrast on the subject.

Steps: Select > Inverse
 Image > Adjust > Curves

The selection was inverted again so that changes would affect the background. The Curves dialog box was opened and the shape of the curve was adjusted. A number of options were previewed before a background appropriate to the time, the mood, and the sensibilities of the subject was chosen.

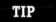

TIP

The Levels controls are excellent for contrast and brightness fine-tuning. Curves can also be used for these controls and also allows for easy preview and application of special effects.

Portraits:
Create the appearance of shallow depth of field

Comment: There are many ways to emphasize specific subjects within a scene; one of the best is to work with depth of field. By making the background slightly soft we still retain the context in which the subject stands. Depth of field control is easily done with Selection and Blur tools.

Image Source: 35mm black-and-white negative

Scan: Photo CD

File Size: 18 MB; after grayscale conversion, 6 MB

■ Image 1

Steps: File > Open > 18 MB
Image > Mode > Grayscale

The mariachi band members were photographed while awaiting the beginning of their concert. A 24mm lens set at an aperture of f/16 was used, which gave a deep zone of sharpness (depth of field). After this print was made, it was decided to feature one of the band members. The aim was to emphasize one member of the group while not obscuring the others.

■ Image 2

Steps: Lasso tool
Quick Mask mode
Airbrush tool
Filter > Blur > Gaussian Blur

In this instance, the best technique for single-subject emphasis was to control the depth of field. Working with a stylus on a drawing tablet, the area around the subject was selected using the Lasso tool. Quick Mask mode was chosen and the Airbrush tool was used to refine the selection. The Gaussian Blur filter was chosen to allow for complete control of the degree of unsharpness. A 5% effect was used, which threw the background slightly out of focus.

TIP

It is often a good idea to "feather," or add a slight blur to the edges of a selection. Feathering builds a transition that gradually blends the edges of any selected area. Before making a selection, set the amount of feathering in the Options palette of the selection tool you are using. After you have made a selection feather the edges by choosing Select > Feather. Values are set according to the needs of each image in a range of 0 to 250; 0 produces no feathering.

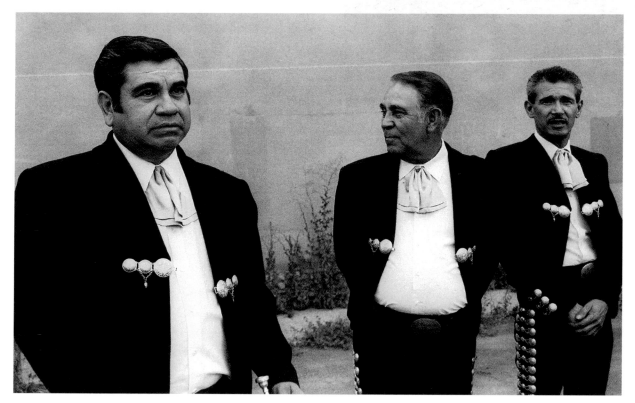

Image 1

Image 2

Portraits:
Create an expressionistic portrait

Comments: At first look you might think that this portrait is lost to excessive shadows and contrast, but knowing that you can manipulate tonality and brightness gives you a powerful tool in rescuing such images. When in the Levels dialog box, keep an eye on the screen preview to see the effect of your actions. As you gain familiarity with the controls you'll see the potential in each image.

Image Source: Medium-format color transparency

File Size: 6 MB; after grayscale conversion, 2 MB

■ Image 1

Steps: File > Open > 6 MB
Image > Mode > Grayscale

The print from the scanned image shows too much background and a fairly flat tonal rendition.

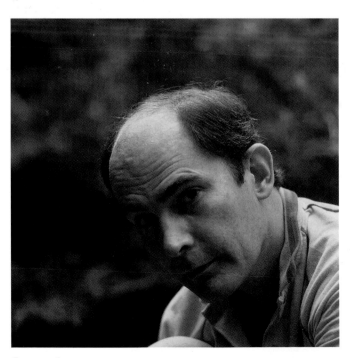

Image 1

■ Image 2

Steps: Cropping tool

When cropped, the image is harsh. The background needs to be controlled, and the face needs to be "opened."

■ Image 3

Steps: Lasso tool
Image > Adjust > Levels
Select > Inverse
Airbrush tool

The face was selected from the background using the Lasso tool and was lightened using the Levels dialog box. The selection was then inverted using the Select > Inverse command, the Levels box was again opened, and the background was darkened. The final step required cleaning up the edges of the selection with the Airbrush tool plus working the shirt to make the highlights less conspicuous.

TIP

The ability to selectively apply techniques to the foreground and background allows for complete image control. Here, a harsh rendition is improved through contrast and brightness controls, an approach that is reinforced through the elimination of a distracting background.

Image 2

Image 3

NOTES